Color

A course in mastering the art of mixing colors

Also by the author:

*The New Drawing on the
Right Side of the Brain*

*The New Drawing on the
Right Side of the Brain
Workbook*

Drawing on the Artist Within

A course in
mastering the art
of mixing colors

Color

Betty
Edwards

Jeremy P. Tarcher/Penguin
a member of
Penguin Group (USA) Inc.
New York

author of
**The New Drawing
on the Right Side
of the Brain**

Most Tarcher/Penguin books are
available at special quantity discounts
for bulk purchase for sales promotions,
premiums, fund-raising, and educational
needs. Special books or book excerpts
also can be created to fit specific needs.
For details, write Penguin Group (USA)
Inc. Special Markets, 375 Hudson Street,
New York, NY 10014

Jeremy P. Tarcher/Penguin
a member of
Penguin Group (USA) Inc.
375 Hudson Street
New York, NY 10014
www.penguin.com

*Library of Congress Cataloging-in-
Publication Data*

Edwards, Betty, date.
 The art of using color: a course
 in mastering the art of mixing
 colors / by Betty Edwards.
 p. cm.
 Includes bibliographical references
 and index.
 ISBN 1-58542-199-5
 ISBN 1-58542-219-3 (pbk.)
 1. Color in art. I. Title.

 ND1488.E35 2004
 2003067215 752—dc22

Printed in the United States of America

1 3 5 7 9 10 8 6 4 2

This book is printed on acid-free paper. ∞

To my granddaughters,

Sophie and Francesca

Contents

Acknowledgments

Those I wish to thank:

Anne Farrell for her invaluable help with the manuscript—editing, researching, suggesting ideas, and preparing the manuscript.

Brian Bomeisler for his many contributions and insights into teaching basic color concepts while team-teaching with me our five-day color workshop.

Jeremy Tarcher for his encouragement and enthusiastic support for this project.

Robert Barnett and his associate Kathleen Ryan for their thoughtful legal support and assistance.

Joe Molloy for his superb design of the book.

Rachael Thiele for her unwavering support and assistance with fine art reproduction permissions.

Mary Nadler for her eagle eye and wise counsel in editing the manuscript.

Wendy Hubbert for her editing skills, especially in the book's structural organization.

Tony Davis for his excellent copyediting.

Don Dame for his color expertise and encouragement during my years of teaching color theory at California State University, Long Beach.

All of the students in our five-day color seminars for their contributions and insights.

My family—Anne and John, Roya and Brian—for their patience and loyal support.

Among all of the writers on color I have read in preparing this book, I am especially indebted to the work of Albert Munsell, Johannes Itten, Enid Verity, Hazel Rossotti, and Arthur Stern for his interpretation of Charles Hawthorne's teaching in *How to See Color and Paint It*, now unfortunately out of print.

Introduction:
The Importance of Color

Generations have trod, have trod, have trod;
And all is seared with trade; bleared, smeared with toil;
And wears man's smudge & shares man's smell: the soil
Is bare now, nor can foot feel, being shod.
And for all this, nature is never spent;
There lives the dearest freshness deep down things;
And though the last lights off the black West went
Oh, morning, at the brown brink eastward, springs—

From *God's Grandeur*, by Gerard Manley Hopkins (1844–89)

Color on Planet Earth

Color signifies life. In our explorations of the solar planets and their many moons, we have yet to find life on any world in space, and therefore the colorfulness of our planet, especially the green of our vegetation and the blue

of our water, appears to be unique. Areas on Earth that teem with life, our jungles and oceans, forests and plains, are filled with natural colors that delight the eye and mind. Even in areas that are colorless because they have been stripped of life by natural disasters or human misuse, nature is never spent, as English poet Gerard Manley Hopkins writes, and with renewed life, color returns.

It is difficult to imagine a world without color. Yet, much of the time we take the importance of color in our lives for granted much as we take for granted the air we breathe. Especially in our modern cities, we barely notice the fantastic abundance and intensity of human-made color, perhaps because, with so much color around us, we have grown used to its passing pleasure. Much of this spreading sea of color has no real function other than to attract attention to itself. Unlike nature, where every color has gradually evolved over time to fulfill some precise utilitarian purpose, and unlike ancient times, when costly colors such as purple were restricted to the finery of the rich and were as precious and meaningful as jewels, we spread color around because we like it, it is available, and we *can*. We modern humans have literally millions of inexpensive colors at our fingertips. A decision to paint a wall, a signboard, or a storefront can be as casual as, "Oh, let's make it yellow (or purple or turquoise or chartreuse)." In buying clothes, at least in most modern cultures, we have free choice of brilliant colors that would have been inaccessible and, more important, *forbidden* to any but the most powerful rulers. Surely, this profusion of colors separated from meaning and purpose has blunted our inherited primordial response to the significance of color.

Yet color, in its mysterious way, continues to matter. Our biological inheritance, perhaps at a subliminal level, still causes certain colors to attract or repel us, to provide helpful information or warnings, and to mark boundaries. In gang-troubled urban areas, wearing the "wrong" color in rival territory can be very dangerous. American

holidays are clearly color-coded: red, pink, and white; red, white, and blue; orange and black; red and green. Pink, even today, is often used to clothe a girl baby, while blue signifies a boy. Red, yellow, and green control street traffic without the need for human direction. In addition, we may use color for subconscious purposes. Did I choose to wear this blue sweater today for a reason? Why did I buy that yellow teapot instead of the white? Consider this: Statistically, automobiles painted dark red are involved in more fatal accidents than cars of any other color. The color of cars least involved in such accidents? Pale blue.

Because scientists have always been intrigued by color, the literature on color is massive. Some of the greatest thinkers in human history were consumed with a passion to understand color, among them the Greek scientist and philosopher Aristotle, the English scientist Sir Isaac Newton, and the German writer and scientist Johann Goethe. Goethe regarded his immense 1810 study, *Farbenlehre* (*Theory of Colors*), his most important achievement, even greater than his masterwork, *Faust.* These and other scientists and philosophers have written huge tomes to ponder the question, "What *is* color?" This seemingly simple question defies an objective, simple response.

Dictionary definitions provide little help. The *Encarta World English Dictionary* gives as its first definition of the word *color*: "Property causing visual sensation. The property of objects that depends on the light that they reflect and that is perceived as red, blue, green, or other shades." But what *is* that "property"? What do objects really look like? The dictionary goes on to provide eighteen additional uses of the word, which still do not really define color but do provide an interesting parallel with the word *draw.* Both words have multiple meanings, illustrating the broad relevance of both concepts. Both can be used as nouns, as in "The contest was a draw," or "The color was bright." Both can be used as verbs, for example, "to draw on previous experience," or "to color one's opinions." Both

There may be a number of explanations for the fatal-accident record of dark red cars and the safety record of pale blue cars:

- **The red color is more difficult to see at night than is pale blue.**

- **Dark red is a more popular color with young drivers, while pale blue appeals to older, sometimes safer drivers.**

- **Red is a preferred color for high-powered sports cars, whereas pale blue is more often seen on sedate sedans.**

- **Red is a color that is traditionally connected with danger and excitement, therefore perhaps attracting less cautious, more adventurous drivers.**

"Color is mysterious, eluding definition; it is a subjective experience, a cerebral sensation depending on three related and essential factors: light, an object, and an observer."

Enid Verity, *Color Observed*, 1980

Do not all charms fly

At the mere touch of cold
 philosophy?

There was an awful rainbow
 once in heaven:

We know her woof, her texture;
 she is given

In the dull catalogue
 of common things.

Philosophy will clip an
 Angel's wings,

Conquer all mysteries by rule
 and line,

Empty the haunted air, and
 gnomed mine—

Unweave a rainbow....

John Keats, *Lamia*, part II, 1884

words can be used as adjectives, as in "She had a drawn expression" or "He uses colorful language." Other examples of broad meaning abound, such as "to draw conclusions," "to draw a line in the sand," "to show one's true colors," and "to pass a test with flying colors."

Regarding the first definition, "property causing visual sensation," can it be true that color is not a thing in itself, but merely an observer's mental sensation caused by light falling on an unfathomable surface? Is a lemon *really* yellow or is the yellow sensation only occurring inside my own mind? Scientists tell us that lemons, whatever color they might or might not be (perhaps *even colorless!*), have particular surface qualities that absorb all light wavelengths except those that reflect a particular wavelength back to my eye/brain/mind system. This specific wavelength causes my visual system to experience a mental sensation that in English is named "yellow." The perceived hue, however, might depend on who is looking at it. Is the yellow I see the same one that you see? What does a color-blind person see? Such questions have baffled human minds for centuries and are difficult for scientists and nonscientists alike to resolve because we cannot get outside of our own eye/brain/mind system to find out. We are simply left with the mysteriousness of color and our singular, individual mental and emotional responses to it.

Leaving these imponderable aspects to scientists and philosophers, what we *do* know is that we like color, whatever it is, and sometimes wish to have a better understanding of how to accurately perceive, combine, and use the beauty of color. We are all aware that certain color harmonies please us in extraordinary ways and we wonder why. We wonder what we need to know to achieve beautiful color arrangements, whether on a page, in our clothing, or in our surroundings.

At the same time, we may fear that knowing too much about color will spoil it for us—that the glory of the rainbow will fade to gray, as Keats's poem so eloquently

warns us. My belief, however, is that joy does not vanish with knowledge. Each of us, in one way or another, needs to make choices about color in our daily lives. Of course, we have our intuitions to guide us, but, in general, intuition combined with knowledge is more powerful.

In this book, I plan to gently unweave the complexity of color to provide you with a strong basic understanding of color—how to see it, how to use it, and, for those working with color, how to mix and combine hues to achieve that most elusive goal, harmony in color. If your interest in color is on a more casual level, the simple exercises will deepen your understanding and enjoyment of color.

In part I of this book, I distill the enormous existing knowledge about color into a brief but complete foundation on the meaning, theories, and language of color.

In part II, I provide practical information on art materials and hands-on exercises that clarify the theory and vocabulary of color.

Finally, in part III, I discuss harmonious color combinations, the meaning and symbolism of colors, and then suggest ways you can use this knowledge to incorporate the joy of color into your daily life.

"If you, unknowing, are able to create masterpieces in color, then un-knowledge is your way. But if you are unable to create masterpieces in color out of your un-knowledge, then you ought to look for knowledge."

Johannes Itten, *The Art of Color*, 1961

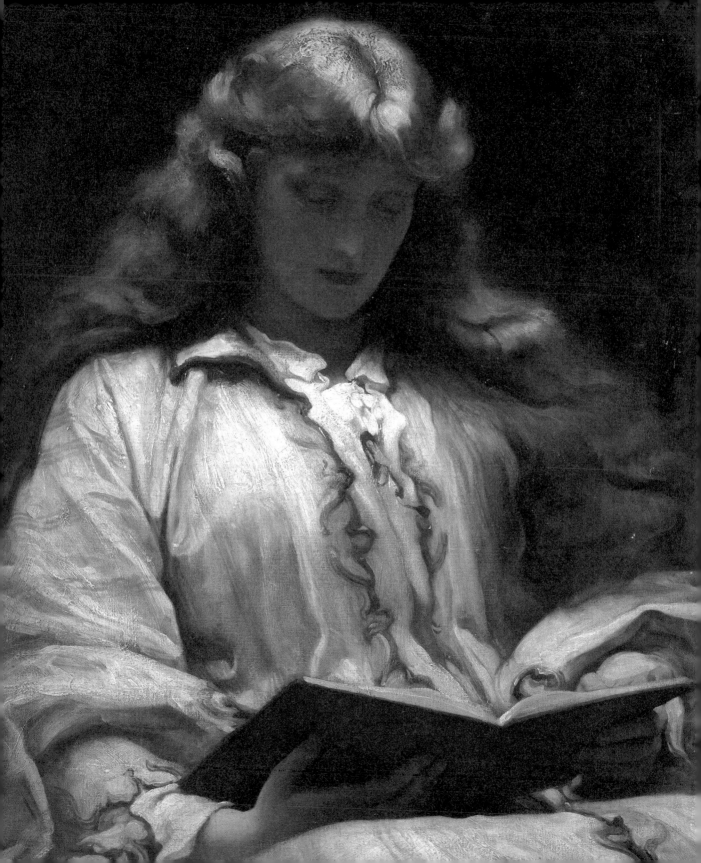

PART I

Drawing, Color, Painting, and Brain Processes

THE STUDY OF COLOR is rarely a part of general education beyond some rudimentary learning in elementary school. After the early grades, only special art classes bring color to students' awareness and understanding. Even then, art students often learn about color only incidentally while they are learning to paint, and drawing is often learned as a subject unconnected to either color or painting. These basic subjects, however, are best learned in sequence: first drawing, then color, then painting.

Though closely linked by various brain processes, these three subjects are, at the same time, quite different. The most obvious difference between drawing and painting is that we usually associate color with painting and not with drawing. A less obvious difference is that painting requires and includes drawing (except, perhaps, in certain abstract and nonobjective styles of painting), but drawing does not include or require painting. For this reason,

students ideally should learn to draw before they take up painting. The third basic subject, color, requires specific training (usually called "color theory") that should come between drawing and painting. The three subjects are similar in that students learn to use various mediums, to depict a variety of subject matters, and, above all, to see in the ways that artists see. One of these ways of seeing that connects drawing, painting, and color is the need to perceive values (changes in lightness and darkness).

Echoing this traditional basic art skills curriculum is the advice I give in my book *The New Drawing on the Right Side of the Brain*, that an artist-in-training ideally should first learn to see and draw edges using line, then progress to drawing spaces and shapes in proportion and perspective. Next, one learns to see and draw values. Then, a student should learn to see and mix colors before putting drawing skills and color skills together in painting. This progression is ideal because, in painting a complicated scene, it helps to know how to *see and draw* before adding the additional challenges of painting, and it helps to know how to see and mix colors before trying to paint. It is interesting to note that the Dutch artist Vincent van Gogh, who was largely self-taught, made up his mind to improve his drawing before he allowed himself the privilege of color. Most of the exercises in this book, however, are so focused on color alone that knowing how to draw, while helpful, is not essential. The exception is the perception of values, a skill you will learn in chapter 6.

Seeing Colors as Values

The most frequent problem experienced by novices in color is the difficulty of seeing colors in terms of values. Since most drawings are in made in shades of gray, students learning to draw also learn how to translate *colors into values*. Students learn to see, judge, and draw colors as *shades of gray* that are relative to a graduated scale from white to

"I already tried it [painting] in January, but then I had to stop, and what decided me, apart from a few other things, was that my drawing was too hesitant. Now six months have passed which have been entirely devoted to drawing...I have attached great value to drawing and will continue to, because it is the backbone of painting, the skeleton that supports all the rest."

Vincent van Gogh, *The Complete Letters of Van Gogh*, vol. 1, nos. 223 and 224.

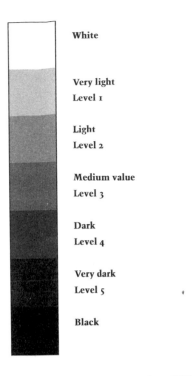

White

Very light
Level 1

Light
Level 2

Medium value
Level 3

Dark
Level 4

Very dark
Level 5

Black

Fig. 1-1.

black, called a "gray scale." Try this out in Figure 1-1. At what value level on the accompanying gray scale would you place that yellow? At what level would you place the purple? Is one color darker, or are they at very nearly the same value level? (The fact that they are nearly the same value level is made even more difficult to see because we habitually think of yellow as pale and purple as dark.)

Why Values Are Important

The value levels of colors are important because dark and light contrasts are fundamental to good composition—that is, how the shapes and spaces, lights and darks, are arranged in a drawing or a painting. Problems with contrast almost inevitably result in compositional problems. For example, in the 1895 English painting *The Maid with the Golden Hair* (Figure 1-2), the artist, Frederic, Lord Leighton, painted the young woman's golden-blonde hair in a range of values from pale gold to almost black, and because he has given us this full range of values, we perceive the sitter's hair as subtly and wonderfully golden. Had Lord Leighton failed to see the light and dark variations in the color of the girl's hair and had he painted it in one value only—say, the pale gold at the crown of the head—the entire composition would have disintegrated.

In the mid–nineteenth century, artists avoided such problems with contrast by painting a complete composition in shades of gray to establish the value structure, from the lightest lights to the darkest darks, before ever adding color. The method was called *grisaille* after the French word for gray, *gris*. Figure 1-3 is a black-and-white photograph of the Leighton painting, showing how it would have appeared as a grisaille underpainting.

A grisaille underpainting (Figure 1-4) is essentially a *drawing in paint*, again illustrating the connections between drawing, painting, and color. With the values of colors translated into shades of gray, the artist could then

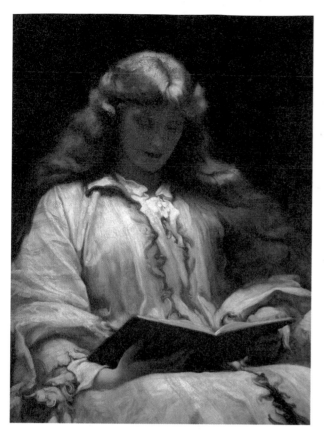

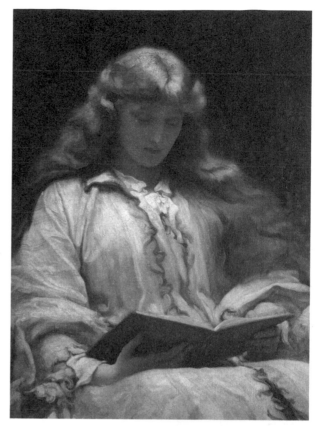

Fig. 1-2. Leighton, *The Maid with the Golden Hair*.

Fig. 1-3.

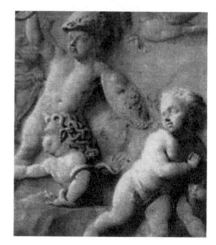

Fig. 1-4. Martin Josef Geeraerts (1707–91), *Allegory of the Arts* (detail), oil on canvas, 45 × 52 cm (17¼ × 20½ in.). Raphael Valls Gallery, London, UK.

mix hues—say, for a blue garment—of the correct lightness or darkness by using the gray underpainting as a guide for adjusting the value of the blue to depict lighted and shadowed areas of the garment. Clearly, this was a difficult and time-consuming method, and most artists abandoned grisaille underpainting late in the nineteenth century. This historical note, however, points up the importance of knowing how to perceive accurately the value levels of colors.

The Role of Language in Color and Painting

Another connection that links drawing, painting, and color involves brain processes. Drawing a perceived subject seems to require mainly the visual, perceptual functions of the nonverbal right-brain hemisphere without interference from the verbal system of the left brain. Color and painting, on the other hand, require the same visual-perceptual functions and input from the verbal, sequential left hemisphere for mixing colors.

Based on my work with thousands of individuals, I have found that drawing one's perceptions requires setting aside verbal knowledge about what one is drawing. Put differently, one must forget the *names* of things by making a cognitive shift from *L-mode*—my term for the dominant language mode of the brain, usually located in the left hemisphere—to *R-mode*, my term for the so-called subdominant visual-perceptual mode generally ascribed to the right hemisphere.

A mental shift to the visual mode causes a slight change in consciousness that is noticeably different from ordinary consciousness, a state of mind often experienced in other activities. Entering the "zone" while playing a sport, for example, is described as a loss of the sense of time passing, intense concentration on the task, and difficulty or even inability to use language. In drawing a perceived subject, an artist experiences this mental state, including a sense of "oneness" of the artist, the thing observed, and the

Donald S. Christiansen, University of Washington sports psychology consultant, lists characteristics of "peak performance," sometimes called "the zone."

The athlete is:

Physically relaxed
Mentally calm
Focused
Alert
Confident
In control
Positive
Feeling enjoyment
Feeling effortless
On "automatic"
Focused on the present moment

developing image of the drawing. I have called this change in consciousness a cognitive shift to "R-mode state." Painting, like drawing, requires this mental shift to the special R-mode visual functions in order for the artist not only to perceive a subject clearly, but also to perceive colors—especially the relationships of colors. One of the main functions of the brain's right hemisphere is to perceive such relationships.

Despite this shared reliance on R-mode, painting seems to induce a somewhat different brain state from drawing, and I believe that the complication of painting materials contributes to that difference. Drawing materials are simple and few: paper, something to draw with, and an eraser. With drawing, the artist's mental state is largely uninterrupted by the need to attend to these minimal implements, and therefore the R-mode state is relatively undisturbed. Most painting mediums, however, such as watercolor, oil paints, or acrylics, require several brushes, a palette of eight, ten, twenty, or sometimes more pigments, a thinning medium such as water, oil, or turpentine, and some knowledge of how to mix colors. Furthermore, mixing colors (especially for a beginning painter) is a verbally linked, step-by-step act requiring a return to L-mode, the more familiar sequential, verbal-analytic mode mainly ascribed to the brain's left hemisphere. Significantly, the artist must frequently *pause to mix colors* many times while painting, each time interrupting the R-mode state.

The mental process of painting, therefore, seems to occur as follows: The artist "paints away" in R-mode until the need arises to mix a particular hue. The artist pulls out of R-mode and thinks about how to mix the hue, often with some unspoken verbal prompts. ("I need a dull blue, medium dark. I'll use ultramarine blue plus some cadmium orange and a little white. Too light. Add more blue. Too bright. Add more orange. Try it. That's about right.") Then comes a return to R-mode that is sustained until the next color mixture is needed.

"In fact, the field of colors is a territory with ragged borders located somewhere between the sciences and the arts, between physics and psychology, a land whose configuration constitutes a border between these two diverse cultures.

"As a result, however, ideas from each side become cloudy and appear easy target for the other, a region of facile conquest not yet wholly ruled by analytic or experimental methods."

Manlio Brusatin, *A History of Colors*, 1991

Fig. 1-5.

The mental state of painting, therefore, can be characterized as an in-and-out or back-and-forth state between R-mode, the somewhat blissful visual-perceptual mode, and L-mode, the more familiar verbal-analytic mode. This in-and-out mental process of painting, caused by the need to mix colors, is almost subconscious for the experienced painter. For a beginner, however, it is a more conscious shift that requires getting used to through practice. Once it is learned, the process of mixing colors becomes easy and rapid and many people come to enjoy the dual-mode aspect of painting.

The Constancies: Seeing and Believing

Accurate perception is the most fundamental requirement for drawing, painting, and color, but various brain processes affect our ability to see what is really out there—that is, to see the true data reflected back to the retina rather than what our preconceptions tell us we are seeing. A brain process called "size constancy" can muddle perception by actually overriding direct information that hits the retina, causing us to "see" images that fit preexisting knowledge. For example, a beginning drawing student asked to draw a frontal view of a chair often distorts the retinal image of the chair seat into a fully round or square shape, even though the retinal image of the seat is a narrow, horizontal shape (Figure 1-5). The reason for this distortion is that the student knows that the seat must be wide enough to sit on. As another example, in drawing a group of people, some nearby and some distant, a novice in drawing will draw everyone about the same size, because the brain refuses the retinal information that the distant persons are perhaps only one-fifth the size of those nearby.

The Power of Size Constancy

For a quick demonstration of this strange phenomenon, stand in front of a mirror at about arm's length and

observe that the reflection of your head looks life-sized. If you reach forward and measure with your hand, however, you will find that the actual size of your reflected head in the mirror is only about four and a half inches long, about half the actual size. Yet, when you remove your hand, the image again looks life-sized! Your brain knows what size your head should be and changes its interpretation of the mirror image to fit that knowledge. The brain, however, doesn't tell you that it has changed the image, and it is only by measuring that you can know. Size constancy is operating all of the time without our knowing it, hence the saying "In order to learn to draw, you must learn to see."

Color Constancy

A similar oddity happens with color. A painter must cope not only with size constancy but also with a parallel phenomenon called color constancy, in which the brain overrides color information received by the retina. Our brains "know," for example, that skies are blue, clouds are white, blond hair is yellow, and trees are green with brown trunks. These fixed ideas, largely formed in childhood, are very difficult to set aside, causing a person to look at a tree, for example, without really seeing it.

The Power of Color Constancy

The following incident demonstrates the power of color constancy to affect perception. An art teacher friend of mine set up an experiment to test color constancy with his beginning painting students. The day before the class, he arranged a still life of various random objects, mainly white Styrofoam geometric shapes such as a cube, a cylinder, and a sphere. Then he set among these neutral objects (that is, objects not necessarily linked to any specific colors) an egg carton full of white-shelled eggs. He added colored flood-lights to make everything in the still life a bright pinkish red. The next day, he met with his students and asked them to do a painting of the still life, giving no further instruction.

"We should not be surprised to find that color constancy creates problems for art students. Color constancies in children are continually reinforced through coloring books, school ditto sheets, and adult reactions: Color the tree green. Color the sky blue. Make the car red. Oh, no! Leaves aren't purple! While such strategies do teach children the culturally agreed object colors, they discourage sensitivity to the rich color effects in the environment and prevent the enjoyment of color as it registers on the retina."

Carolyn M. Bloomer, *The Principles of Visual Perception*, 1976

"We do not see any of the colors pure as they really are, but all are mixed with others; or if not mixed with any other color they are mixed with rays of light or with shadows, and so they appear different and not as they are."

Plato, in Mary Ann Rouse and Richard H. Rouse, "The Text called *Lumen Animae*," *Archivum Fratrum Pradicatorum* 41 (1971)

The results were remarkable. Every student painted the white Styrofoam objects in shades of pinkish red just as they appeared under the colored light—but not the eggs! In every case, the students painted the eggs—yes, you guessed it—white. The concept "eggs are white" overrode their actual appearance caused by the colored lights. Even more remarkable, when the teacher called this to the students' attention, they looked again at the arrangement and still insisted, "The eggs *are* white." It was only by using the special device I will introduce to you in chapter 10 that they could see the true color of the red-lit eggs. In the following chapters, I will teach you techniques for setting aside powerful preconceptions and seeing the true richness and variety of colors.

The Purpose of the Constancies

The purpose of the constancies is efficiency. The brain does not want to make up its mind, so to speak, every time conditions such as light, distance, or unusual orientations change the appearance or size of familiar objects. An orange is seen as that color even when seen in a blue light. Even at a distance, an automobile seems to be normally full-sized, and a table is recognized as a table despite considerable differences among tables. We mostly see what we have learned to expect to see. Penetrating this mind-set and breaking through the constancies requires new ways of perceiving—just one of the important skills that you will learn by doing the exercises in this book.

Seeing How Light Changes Colors

In addition to the constancies, another complication in seeing colors is the variability of light. For example, as the sun's angle relative to the earth changes during the day, the apparent color of an object will change. The yellowish light of midmorning will cause red to become more orangish, and the bluer light of late day will shade the red toward purple.

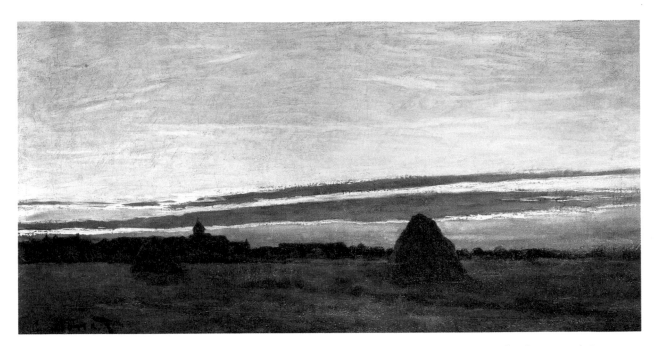

The brain resists acknowledging these changes, however,
and a red flower will seem the same red throughout the day.

French artist Claude Monet (1840–1926) had an
insatiable desire to see and understand how colors change
under varying conditions of light. In his zeal, he painted the
same subjects, such as haystacks or church facades, from
the same viewing point, over and over during the course of
many days. He would go out each day at sunrise carrying
ten or more canvases and work until sunset. Every hour or
so, as the light changed from dawn to midday to dusk, he
would set aside one partially painted canvas and take up
the next to capture his new impressions. The following day,
he would return at sunrise with the same set of canvases
to work all day again on each painting in succession. The
resulting paintings are astonishing. Each fleeting impres-
sion of the identical subject has its own color arrangement
(Figure 1-6). Monet's work reveals to us the fantastic com-
plexity of unique, subtle hues to be seen at every moment
if we can set aside the preconceptions that limit our color
perception.

Seeing How Colors Affect Each Other

Not only do different light conditions affect how we perceive colors, but we also see colors differently depending on surrounding or adjacent colors. The effects of adjacent colors are not always predictable, making this a genuinely intriguing and captivating complication, and it is possible that no two people see exactly the same effects. You never quite know what will happen when you place one hue next to another. For example, as shown in Figure 1-7, we can make one color look like three different colors by surrounding the hue with three different backgrounds. In each case, the blue centered in the colored squares is exactly the same blue, yet the blue on a pale yellow background seems darker than that on dark green, and the blue on orange seems brighter than either of the first two. The colors have a back-

Fig. 1-7.

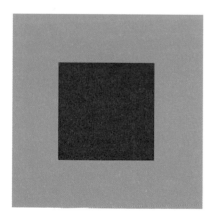

Fig. 1-8.

and-forth effect on each other and on our perception of their relationships, an effect known as "simultaneous contrast."

Some aspects of simultaneous contrast are quite surprising. For example, when bright red is surrounded with bright green, we see a shimmer at the edges where the two colors meet (Figure 1-8). Red and green are highly contrasting colors called *complements*, an important aspect of color we will take up in chapter 3. When complements are placed edge to edge, the juxtaposed, heightened contrast causes us to see the apparitional shimmer. In addition, when we surround a single shade of gray, made of just black and white,

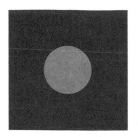

Fig. 1-9.

with different colors, the gray will seem to take on a faint tinge of each surrounding hue (Figure 1-9). Traditional Asian artists make lovely use of simultaneous contrast in landscape painting. By surrounding an unpainted circular area in the sky (representing the sun or the moon) with a gray tone, the unpainted area seems to glow with an inner light that is whiter than the actual color of the unpainted paper (Figure 1-10).

All of these complications—the mysteriousness of color and our difficulty in defining it, clearly seeing it, and knowing how to use its physiological, psychological, and emotional hold on us—can seem daunting to someone interested in color. Nevertheless, there exists a core of practical knowledge, worked out by artists over many centuries, about how to see, mix, and combine colors. This core knowledge, while based on the voluminous color theory literature, focuses on the actual practice of working with color and is relatively straightforward and comprehensible. In the chapters ahead, I will first briefly review the relevant color theories and then take up the practical aspects of seeing and using color. Given the importance of color to modern life and modern science, and the great pleasure we take in color, this learning can be enormously rewarding.

Dr. L. Garwood, head of Ophthalmology at St. John's Hospital in Santa Monica, California, believes that as many as one in eight American men are, to some degree, color-blind.

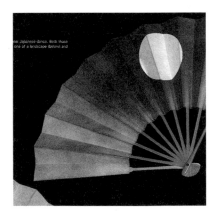

Fig. 1-10. Sadao Hibi, *Dance Fans*. From Hibi's book *The Colors of Japan*, 2001.

Understanding and Applying Color Theory

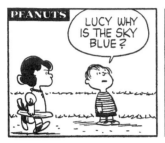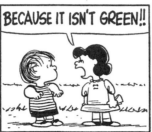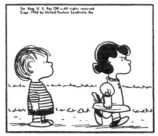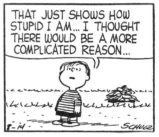

Charles M. Schulz. *Peanuts*, **August 14, 1958. © United Feature Syndicate, Inc.**

OUR FASCINATION WITH COLOR begins very early in life. Surely, every child has asked, "Why is the sky blue?" To answer that question and countless others about color, scientists have developed a body of knowledge known as "color theory." Color theory is the study of rules, ideas, and principles that apply to color as a general topic, somewhat apart from the artist's actual practice of working with colored pigments. In this book, my central purpose is to teach you how to see and mix colors to match perceived hues, and how to combine colors to create harmonious arrangements. To this end, some background information about modern and traditional color theory is useful, since we will be drawing on centuries of artists' practical knowledge of working with pigments—knowledge that artists themselves derived from color theory.

Theories about Color

In the Western world, theories about color have a clear history of development, beginning with the ancient Greeks, who thought that colors arose from the struggle between light and darkness. Aristotle considered red to be midway along a continuum from white to black, with the other hues arranged accordingly—yellow nearer to white and blue nearer to black. He thus conceived a *linear* ordering of colors based on the paleness or darkness of pure hues, a theory of color ordering that persisted for over two thousand years—from the sixth century B.C. to the seventeenth century A.D.

Then, in the late 1600s, Sir Isaac Newton used a glass prism to divide white rays of sunlight into the fanned colored wavelengths, which he named the *spectrum*, derived from a Latin word meaning *apparition* (Figure 2-1). Newton assigned names to the radiant colors: violet, indigo, blue, green, yellow, orange, and red. He diagrammed the seven spectral hues into a closed ring that followed the ordering of the colors as they appeared in the spectrum and in the rainbow, thus creating the first *color wheel*. Newton placed white at the center of the circle to symbolize the synthesis of all hues into white light. Black was not part of Newton's ring (Figure 2-2).

In 1704, Newton published his theoretical study of color, *Opticks*, which immediately raised a storm of controversy because it contradicted the centuries-old Aristotelian linear conception of color. Even a full century later, writer and scientist Johann Goethe scathingly wrote about Newton's work, "Go ahead, split the light! You try to separate, as you often have, that which is one and remains one in spite of you." Newton's theory prevailed, however, and even Goethe eventually came around, more or less, to agreement.

The great advantage of Newton's color circle over preceding linear orderings was that it revealed color rela-

Fig. 2-1. Freehand sketch by Newton of one of his experiments on color and light.

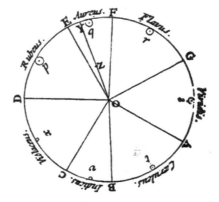

Fig. 2-2. Newton's color circle from his *Opticks*, 1706.

Newton believed that there was a correspondence between sounds and colors. Perhaps because of this mind-set, he decided that he saw seven colors in the rainbow—note that there are two blues, *indigo* and *blue*.

In this way, he aligned his diagram with the seven tones of the musical octave. Scientists continue to study this music/color analogy today.

Fig. 2-3a. Color hemisphere by Michel-Eugène Chevreul (1861).

Fig. 2-3b. Color cube by Charpentier (1885).

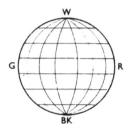

Fig. 2-3c. Color sphere by P. Otto Runge (1810).

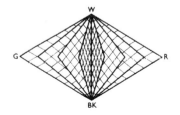

Fig. 2-3d. Color body by Wilhelm Ostwald (1916).

tionships. Artists and researchers could *see* that adjacent hues are related by color, not just by lightness or darkness, and that colors of the highest contrast are located directly opposite each other on the wheel. After Newton, color theorists devised many variations of the color circle, linking hues by enclosing within the circle a square, a triangle, or any multisided geometrical shape, such as the pentagon or hexagon, and even expanding the circle into actual three-dimensional structures (Figures 2-3a–d). Many excellent books are available that describe the work of the great color theorists, philosophers, and aestheticians from Newton and Goethe to the later famous writers on color: Runge, Chevreul, Rood, Itten, Wittgenstein, Munsell, Ostwald, and Albers. Each was searching for a framework or system that would explain relationships among colors and provide artists with rules and principles that would clarify the complications of color.

Throughout the centuries, scientists have studied the relationship of color to human life. Over the last hundred years, color has also become an extremely important aspect of studying the structure of the universe based on spectrographic analysis of the stars, and scientists use elaborate computer-based color systems for this study. Other contemporary scientists have made great progress in understanding the physics of light and how light is converted into neural signals processed within the human eye. Still unresolved, however, are questions about how the brain interprets these neural signals. In many ways, even when the most advanced instruments are used, the physiology of color perception remains a largely unsolved mystery—and, incidentally, the human eye can still perceive just barely noticeable differences among colors better than any of the machines available.

In terms of color in art, the most important twentieth-century contributions to artists' and designers' color usage are the detailed numerical and alphabetical classification systems that were developed mainly for industrial

and commercial use. One result of having codified color systems is the abundance—even overabundance—of manufactured color in modern life. In addition, however, the classification systems have brought many advantages to those interested in art and design. For example, the pigments, dyes, and inks we buy are reliable and consistent, excellent color reproductions of great art are now inexpensive and widely available, and designers can precisely specify colors for manufactured commercial products.

Applying Color Theory in Art

Artists seeking to better understand their craft have avidly studied and followed various theoretical systems and adapted them to practical applications in their studio practices. Some have used a single system exclusively in their painting. For example, the French nineteenth-century painter Georges Seurat developed his pointillist technique (small dots of pure color that blended in the observer's eye) based largely on the 1839 publication of French chemist Michel-Eugène Chevreul's illustrated book, *The Law of Simultaneous Contrast of Colours*, and, later on, Ogden Rood's 1879 book, *Modern Chromatics* (Figures 2-4a and b).

Fig. 2-4a. Georges Seurat (1859–1891), *A Sunday on La Grande Jatte—1884*, 1884–86, oil on canvas, 207.6 × 308 cm (81¾ × 121¼ in.). Helen Birch Bartlett Memorial Collection, The Art Institute of Chicago.

Fig. 2-4b. Seurat, *A Sunday on La Grande Jatte* (detail).

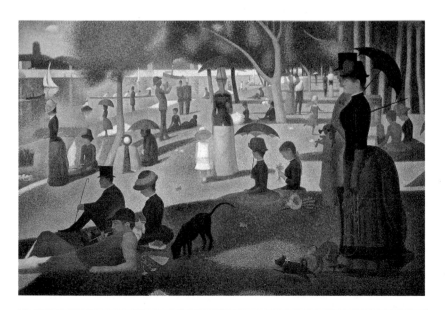

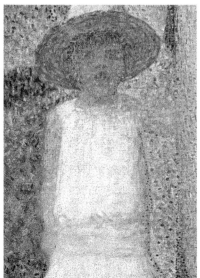

Each of the color theories has inspired loyal adherents among artists. For someone who has never painted, however, the intellectual knowledge gained from classical color theory does not seem to transfer easily to *using* color in painting and in daily life. I believe these skills are best acquired by actually working with pigments, first to understand the basic structure of color as represented by the twelve-color wheel (the most widely used image of color theory), and then how to manipulate pigments with a goal of achieving harmonious color.

Fifteen years ago, a teaching experience clarified for me the relationship of color theory to painting. I began teaching color theory to university art students, a course that students took after beginning drawing and before beginning painting. The course had an official outline, a textbook covering historical color theory as outlined above, and required exercises consisting mainly of pasting together colored paper chips to illustrate aspects of the various theories, a method derived from the great American artist, teacher, and color expert Josef Albers.

My course was successful and popular with students, and the color exercises were attractive to look at, constructed as they were from special coated paper that comes in a huge array of marvelous colors. One day, however, I encountered a student who had done well in my class and was now taking beginning painting. I asked how he was doing. He said, "I'm having lots of trouble. I just can't mix colors, and my paintings look terrible."

"But you did so well in my class," I said.

"Doesn't help," he replied.

Dismayed, I searched out other color theory students and heard the same thing again and again. Clearly, my course was *not* successful in one important way: students' understanding of color theory was not transferring to the practice of using color.

Consequently, I rewrote the course. I threw out the official course outline and the textbook. No more paste, no

more colored paper. We were going to learn color theory by mixing paint. I devised an exercise that encompassed the basic structure of color, involving accurate perception of hues and manipulation of color across its three attributes: hue, value, and intensity. The exercise was challenging but engaging and I could see that students were really beginning to understand how to see and mix colors.

The main surprise, however, came when the exercise, designed only as a teaching tool, was finished. The resulting students' paintings were surprisingly beautiful, displaying color that was marvelously harmonized and satisfying to the eye. With permission, I showed the students' paintings in the public exhibit hallway of the art building, where two of the paintings were bought right off the wall—a rare event with student work.

Studying the paintings, I came to realize that their beauty came from locking hues into a coherent, harmonious relationship that excluded the possibility of any irrelevant or clashing color. Moreover, the method had forced the students to include low-intensity hues—colors that novices often avoid because they seem muddy or dull. Yet, properly mixed in relationship to bright or clear colors, these are the very hues that provide rich, resonant anchors in a color composition.

Later reports from students who had moved on to beginning painting were uniformly positive. The method I had devised obviously worked, freeing students to explore color—including discordant color—from a firm foundation of understanding harmonious color. In the following chapters, therefore, we will be using existing color theories as these have been incorporated into the time-honored practical knowledge of artists, but the emphasis will always be on *what works* in terms of using color. The next step is to acquire a working vocabulary of color that is essential to seeing, naming, and mixing colors to match your perceptions.

CHAPTER 3

Learning the Vocabulary of Color

SINCE LANGUAGE plays an important role in color, simply being able to use the vocabulary of color is immensely helpful in seeing, naming, and mixing colors. The basic vocabulary, derived from color theory, consists of fewer than a dozen essential terms. I present these terms in this chapter, and I urge you to learn and memorize them. The purpose is to set in your mind the *language structure* of color developed over the centuries by artists and color theorists. This will help you to understand and put into practice the fundamental principles of seeing and using color.

The goddess of memory in Greek mythology was Mnemosyne (pronounced ni-*mo*-sen-ee). Her name has come down to us as the word *mnemonic*, meaning "memory aid." The color wheel is a truly valuable memory aid for artists, who often keep one tacked up in the studio for quick reference. For the rest of this book, the color wheel will be

our mnemonic, and, because of its importance, you will construct one in chapter 5. This may sound like a return to sixth grade, but, again, remember its origin in Newton's great intellect.

Color expert John Gage has written that when Newton "rolled up" the rainbow hues into a circle (Figure 3-1), he brought two powerful ideas into being: First, color relationships are more easily visualized and memorized when arranged in a circle; second, that with colors so arranged, the inherent, locked-in relationships of the spectral hues are evident—the *similarity* of colors adjacent to each other on the wheel, and the *contrast* of colors opposite each other. These newly perceived relationships gave rise to the vocabulary of color still used today.

For example, the technical terms that describe Newton's similarity and contrast are, respectively, *analogous hues* (colors next to each other on the wheel) and *complementary hues* (colors pairs opposite each other on the wheel). These very useful terms are of prime importance, but, to understand them, we first need to identify the three basic sets of colors that make up the twelve-hue color wheel: the primaries, the secondaries, and the tertiaries.

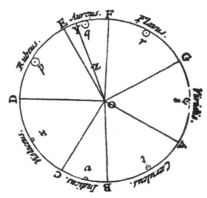

Fig. 3-1. Newton's color circle from his *Opticks*, book I, part II, London, 1704.

The Three Primary Colors

The three spectrum colors yellow, red, and blue are equidistant from one another on the color wheel. To help you visualize and recall their positions, keep in mind that they can be connected by an imaginary equilateral triangle within the circle (Figure 3-2). These three colors are the basic building blocks of color for the artist; they are called "primaries" because you must have them to start with. *You cannot make spectrum yellow, spectrum red, and spectrum blue by mixing any other pigments.*

Theoretically, all other colors—up to sixteen million or more—are mixable given just these three spectrum hues. In practice, however, the chemical limitations of the

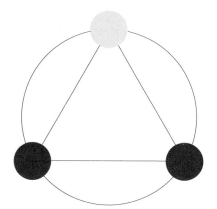

Fig. 3-2. Notice that the three primaries are connected by an equilateral triangle within the circle.

Fig. 3-3. Cyan, yellow, and magenta: the three primary colors of printing.

To complicate color even more, the three primary colors of light (the so-called additive colors) are green, red, and blue. Perception expert Carolyn Bloomer explains:

"Additive colors apply to computer and video images and to theatrical lighting. The screen of a color TV or computer monitor is made up of tiny dots of light (called *phosphors*) grouped in red/green/ blue sets (known as *pixels*). The phosphors emit colored light when excited by electrons; the amount of light emitted depends on the number of electrons striking it.

Varying the red, green, and blue combinations of phosphor excitement within the pixels can produce a full range of colors. You can see the pixels on a TV or computer screen by looking at it through a strong magnifying glass."

Bloomer, *The Principles of Visual Perception*

pigments themselves undermine this theory, illustrating, incidentally, one of the ways that actual practice diverges from theory. As you will see below, artists' colors are not necessarily true spectrum colors. Trace chemicals, especially in the red and blue pigments, reflect light rays other than single, pure wavelengths, causing problems in mixtures with other pigments. Therefore, artists must supplement the three primaries by buying additional pigments whose chemical structures do yield clear hues in mixture.

At this point, I will digress for a moment to make note of an argument that has been going on for many years: whether there exist three primary *pigments* for painters that work as well as the primary inks, dyes, and chemicals used in printing and dyeing. Those primaries are *cyan*, a deep greenish blue, *yellow*, and *magenta*, a brilliant purplish pink, and they reflect the pure spectrum wavelengths without distortion (Figure 3-3). Cyan, yellow, and magenta are aligned with the physiology of human color perception and, in printing, yield all colors from just those three. Life for the painter would be much simpler with readily available, fade-proof, reliable, nontoxic true spectrum primary pigments, especially in oil paints, watercolors, and acrylics, from which all colors could be derived.

So far, it hasn't happened. True, you will find many art materials catalogues listing "Spectrum Cyan," "Spectrum Magenta," and "Spectrum Yellow." I've tried these pigments, and in every case, have returned to the traditional palette of colors I list for you in chapter 4. Later on, you may want to try these spectrum colors if you are curious, and you may find pigments that give better results than I was able to achieve.

I have no doubt that chemists will eventually succeed in formulating true red, yellow, and blue pigment primaries. For now, however, our only true pigment primary is among the yellow pigments. Because of limitations in red pigments, the artist needs two reds to start; among our blue pigments, there is no ideal primary blue.

The Three Secondary Colors

Orange, violet, and green are called "secondary colors." Like the primaries, these three hues are equidistant from one another on the color wheel. They are called secondaries because each is theoretically born of primary parents: orange derives from red and yellow, violet from red and blue, and green from blue and yellow. In theory, you should be able to mix the secondary hues from the primaries; in practice, however, the results are very muddy hues. Again, this is due to the chemical limitations of artists' pigments. Since at present there is no way around this problem, the painter learns to deal with it by buying these three secondary colors as separate pigments.

Fig. 3-4. The three secondary colors are connected by an upside-down equilateral triangle. Together, the primary colors and the secondary colors form a six-sided star.

The Six Tertiary Colors

The tertiary (pronounced *ter*-she-air-ee) colors are the third-generation hues. Each is formed by combining a primary and a secondary hue. These six intermediate colors all have hyphenated names that indicate the two source colors: *yellow-orange, red-orange, red-violet, blue-violet, blue-green*, and *yellow-green*.

Looking at the color wheel in Figure 3-5, you will see that yellow-orange (a tertiary) lies between yellow (a primary) and orange (a secondary). Note that for all six tertiaries, the name of the primary comes first: *yellow*-orange, *red*-violet, *blue*-green, and so on.

Analogous Colors

Fig. 3-5. The six tertiary colors.

Analogous colors are any colors lying next to each other on the color wheel, such as orange, red-orange, and red. Analogous colors are inherently harmonious because they reflect light waves that are similar. Usually, analogous colors are limited to three, such as blue, blue-green, and green. A fourth—yellow-green, for example—is allowable, and

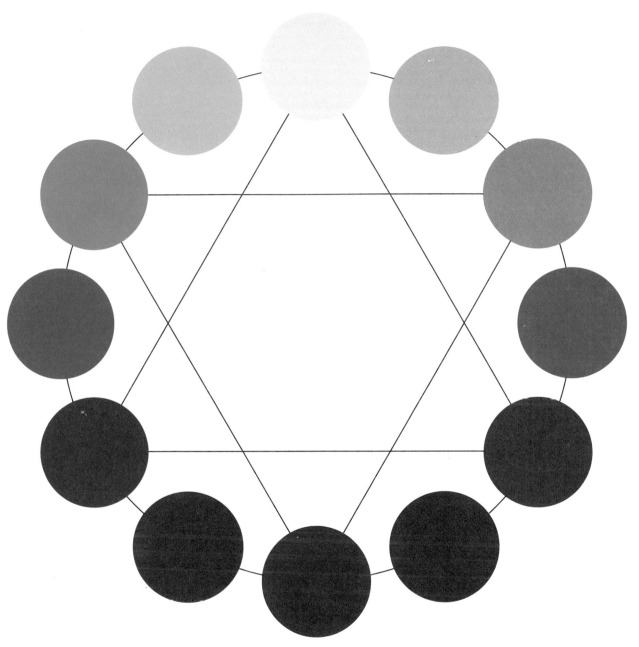

Fig. 3-6. Notice that each of the six tertiary colors comes in between two points of the six-pointed star formed by the primary colors and the secondary colors.

possibly a fifth, yellow, as shown in Figure 3-6. The next color on the circle, however—yellow-orange—will cancel the analogical sequence because the orange in yellow-orange is *opposite* blue on the wheel and reflects opposing wavelengths.

Analogous colors, therefore, can be thought of as small slices of the color wheel—three, four, or, at most, five color wheel hues (Figure 3-7). Lord Leighton's painting *The Maid with the Golden Hair* (Figure 1-2 on page 5) is a study in the analogous colors yellow, yellow-orange, orange, and red-orange, with just a touch of blue-green to provide complementary contrast.

Fig. 3-7. Analogous colors from yellow to blue.

Complementary Colors

Complements are pairs of colors that are opposite each other on the color wheel. My students sometimes mistake the word "complement" for the word "compliment," thinking that complementary colors are colors that go well together. Not so. The true meaning of the word complement is "to make complete" or "to perfect something." In color, complementary colors complete and perfect the central, fundamental role of the primary colors as the theoretical parents and progenitors of all colors. *Any two complements contain the complete trio of primaries.* Even though the artist's primary pigments are not perfect, as you have seen, the following statements are theoretically true. Refer to the color wheel on page 24 (Figure 3-6) to check the following statements:

- Yellow and its complement, violet (made up of red and blue), complete the primary trio—yellow, red, and blue.
- Red and its complement, green (made up of yellow and blue), complete the three primaries.
- Blue and its complement, orange (made up of yellow and red), complete the primaries.

The color of artists' pigments is determined by the wavelengths of the portion of the light ray that remains after the rest has been subtracted out. Hence, pigment mixing is referred to as a *subtractive* process—color being the remainder.

Yellow pigment, for example, is a chemical substance that absorbs all light wavelengths *except* those that reflect the wavelength we perceive as yellow.

As perception expert Carolyn Bloomer states, "...paint pigments do not reflect a single wavelength. Instead, they reflect a wider portion of the spectrum... Hence, any paint color is actually a mixture of colors. Artists must work empirically, with impure materials" (*The Principles of Visual Perception*).

The tertiary colors and their complements follow the same rule. Each pair of tertiary complements is made up of the three primaries. For example, yellow-green is the complement of red-violet (Figure 3-8). If you think it through, you will see that yellow-green contains yellow and green (made from blue plus yellow). Its complement, red-violet, contains red and violet (made from red plus blue). These tertiary complements, therefore, also contain the complete primaries—yellow, red, and blue—again perfecting the primary triad.

Any pair of complements, therefore, does indeed contain all three primaries. In fact, many individual hues also contain the three primaries. *No matter how remote a hue may seem to be from the color wheel primaries of red, yellow, and blue, that hue is likely to contain all three primaries.* Take, for example, the light brown color of a paper bag: This color is actually a pale, dull orange (dulling orange yields brown) made of red mixed with yellow to make orange, lightened with white, then dulled with orange's complement, blue (Figure 3-9).

Summing up, the first secret to knowing how to mix a color that you see is in understanding the structural relationships of the color wheel: primary, secondary, and tertiary hues; analogous colors; and complementary colors. The next step is knowing how to identify the three *attributes* of a color: hue, value, and intensity.

Naming Colors: The *L-Mode* Role in Mixing Colors

In order to mix colors, you must first name, or identify, them in terms of their three attributes: hue, value, and intensity. The reason colors must be named by using this special language of color is that there is almost never a direct match between the colors that we see and the pure pigments that we must use to mix those colors. It would require hundreds, perhaps thousands, of tubes of paint to make direct matches possible. In actual practice, the num-

Fig. 3-8. Every pair of comple-
ments such as yellow-green and
red-violet contains the complete
trio of primaries: red, yellow,
and blue.

Fig. 3-9. Even the color of a
brown paper bag contains all
three primaries.

ber of pure pigments we work with is usually about eight to ten—the three primary and three secondary hues of the color wheel, plus black and white and perhaps two or three additional basic colors. Confronted with colors such as an overcast sky or a peach-colored rose, the artist has no corresponding pigments to match those hues. To achieve these colors, the artist must mix them, using the attributes of a color as a three-part description in order to unlock the "recipe" for mixing that specific color. The next section explains the attributes of color.

The Three Attributes of Color: Hue, Value, and Intensity

To be able to mix any color he or she sees, the artist must first learn how to see into a perceived color in order to identify: (1) the *hue*, (2) the *value*, and (3) the *intensity*. The perceived color is then mixed based on that guiding recipe. Every color existing in our world can be identified by this three-part description. To name a color, we first name the *hue* by identifying the basic source of the color (one of the twelve color wheel hues). Next, we determine the *value*— the color's lightness or darkness. Last, we state the *intensity*—the color's brightness or dullness.

In a way, naming a color by its attributes is similar to identifying an object. We ask ourselves first "In what category is this object?" then "What is its size and shape?" and, last, "Of what material is it made?" The object might be, for example, a box, six inches long, rectangular in shape, made of wood. It might be a vase in the shape of a cylinder, twelve inches high, made of glass. These descriptions are precise enough to give us a fair understanding of the object. The same self-questioning process also works for naming colors. An artist painting a scene is confronted again and again, until the painting is finished, with the question "What is that color?"

Naming the Hue

To answer that question, the artist must first name the first attribute, *hue*. Figure 3-10 shows a color that might be called "lavender" or "mauve." Those "fashion" names are not helpful if you are trying to mix the color you see. You need to say to yourself, "Putting aside for a moment the lightness or darkness of this color as well as its brightness or dullness, which of the basic twelve color wheel hues is the starting point for the hue in Figure 3-10?" You then (correctly) decide that the starting point is the color wheel tertiary red-violet.

Naming the Value

The question you ask yourself to determine this second attribute is "How light or dark is this red-violet relative to a seven-step value scale from white to black?" For this step, compare the color in Figure 3-10 to the value scale in Figure 3-11. You decide that the red-violet is light (level 2). You have now named two of the three attributes.

Fig. 3-10. The color "mauve."

The first step in naming is to state the color wheel source of this hue: red-violet.

Note that the "fashion" name of the color, *mauve*, is not useful for mixing, because you have no such pigment color.

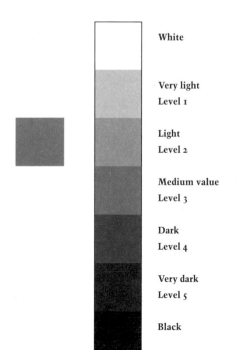

White

Very light
Level 1

Light
Level 2

Medium value
Level 3

Dark
Level 4

Very dark
Level 5

Black

Fig. 3-11. Value scale next to mauve.

Note that we are using only seven steps from white to black and (in Figure 3-12) seven steps from a spectrum hue, such as orange, dulled by its complement, blue, to no color for an intensity scale.

In practice, there can be hundreds of minute value steps from white to black and intensity steps from a pure hue to no color.

Research shows, however, that seven or so value and intensity steps are about the maximum a human can retain in visual memory.

Fig. 3-12. Intensity scale next to mauve.

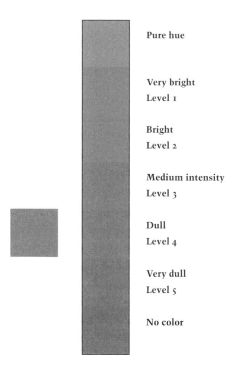

Pure hue

Very bright
Level 1

Bright
Level 2

Medium intensity
Level 3

Dull
Level 4

Very dull
Level 5

No color

Naming the Intensity

The third attribute, intensity, is the brightness or dullness of a color. The question you ask yourself is, "How bright or dull is this color relative to an intensity scale from the brightest color possible (one of the pure color wheel hues) to the dullest color possible (where the color is so dull you cannot discern any hue at all in it)?" Consulting the intensity scale in Figure 3-12, you decide that the hue is dull (level 4). You have now identified the color by its three descriptors:

Hue:	Value:	Intensity:
Red-violet	Light	Dull

You can then proceed to mix the hue by mixing white with red-violet and dulling it with red-violet's complement, yellow-green, since adding a color's complement is the best way to lower its intensity.

From Naming to Mixing

Let's use a hypothetical example of an artist at work to demonstrate how you will go from learning the vocabulary of color to how you will use the vocabulary in seeing and identifying colors. Imagine an artist painting a landscape, which includes a weathered brick wall. The sun shines on part of the wall, and the painter is at the point in the work that she needs to mix a hue for that part of the painting. She must decide, "What is the color of that sun-drenched section of the wall?" This requires, first and foremost, *seeing* what the actual color is, naming it, then mixing it.

The artist looks closely and perhaps feels surprised that the bright sunlight has changed her *expected* color of the bricks (in terms of color constancy, the whole wall "should be" brick red). A novice in color might identify the hue as "beige," but the experienced painter knows that is not descriptive enough to mix the color. She first needs to know which of the pure color wheel pigments is the basis of the hue, because those are the colors she has on her palette. Even though the color is very pale and dull, she sees that the underlying tint is reddish and orangish and therefore knows that the base color of the mixture will come from the color wheel tertiary, red-orange. (This sounds more difficult than it is. Remember, there are only twelve basic color wheel hues, all derived from three primaries, yellow, red, and blue.)

Next, the artist must determine the value level and intensity level. By mentally comparing the value of the wall color with an imaginary scale from white to black, the painter decides that the value is very light (about level 1, just below white). Then, she compares the intensity level to an imaginary 1- to 7-level scale from the brightest to the dullest level for that particular color wheel hue, red-orange, and she is then able to decide that the wall color is of medium intensity (about level 3). Now the artist can name the perceived color by citing its three attributes: "the hue

You will encounter many variations in color terminology, a problem that contributes to the complication of color.

The following list includes the most frequent variations:

Value:
 Shades
 Tints
 Luminance
 Luminosity

Intensity:
 Chroma
 Chromaticity
 Saturation

Gray scale hues:
 Neutrals
 Achromatics

Hue, value, and intensity, however, are the simplest and most widely used terms for the three attributes of color.

Fig. 3-13. Value and intensity scales.

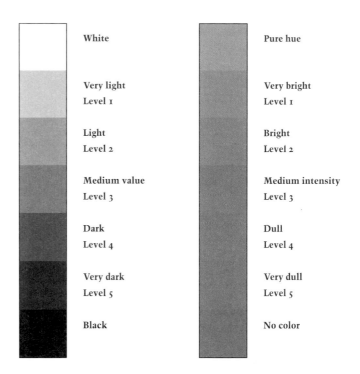

White		Pure hue
Very light		Very bright
Level 1		Level 1
Light		Bright
Level 2		Level 2
Medium value		Medium intensity
Level 3		Level 3
Dark		Dull
Level 4		Level 4
Very dark		Very dull
Level 5		Level 5
Black		No color

is red-orange, the value is very light (value level 1), and intensity is medium (level 3)." Figure 3-13 shows examples of value and intensity scales.

Having *seen into* the color on the brick wall and having identified it in terms of its three attributes, the artist can begin mixing the color, perhaps with some unspoken verbal prompts. "I first need some white, then cadmium red and cadmium orange to make a pale red-orange. Next, I need to *dull* the color. Let's see, the opposite of red-orange is blue-green. I'll mix permanent green and ultramarine blue to make blue-green for dulling the pale red-orange."

When the mixture looks right (meaning *red-orange, very light*, and *medium intensity*), the painter tests it either on a scrap of paper or in the painting itself. Seeing that the mixture has gone a bit too dull, she perhaps adds a speck of yellow to restore colorfulness lost through lightening the

When the color you are about to mix is pale or high in value, it is usually best to start with white and then add the colored pigments.

If you reverse that order, you may find that it takes a great deal of white to lighten the "strong" hues sufficiently. Often, you end up with a great blob of paint on your palette when you may have needed only a small amount.

red-orange with white. (I explain this in a later chapter.) Once the mixed hue is right, the artist then turns back to the painting to reenter *R-mode* and continue her work. Note that the actual time it might take for the whole seeing, naming, and mixing process described above is likely to be no more than a minute, or two at most.

Moving from Theory to Practice

You now have the essential information you need to start putting into practice what you have learned about color. Before we leave these language-based aspects of color, however, I urge you once more to be sure you have memorized the vocabulary of color: the names of the three primary, the three secondary, and the six tertiary hues; the meaning of the terms analogous and complementary colors; and the attributes of color—hue, value, and intensity. I urge you also to retain your awareness of the complications of seeing color, which you read about in chapter 2: color constancy (seeing only colors you expect to see), simultaneous contrast (the effects of adjacent colors on each other), and the unexpected effects of light on color. As we start working with paint in the chapters ahead, you will put this language foundation to good use in seeing color with new eyes.

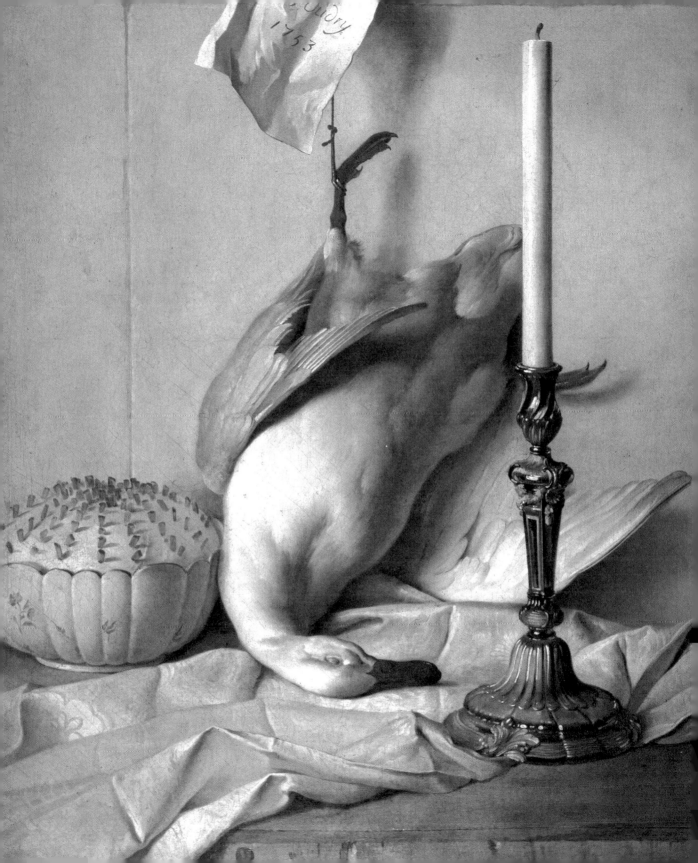

PART II

CHAPTER 4

Buying and Using Paints and Brushes

IN THIS CHAPTER, you will find a set of exercises I have designed to help you learn about colors in the most practical way I know—by mixing and painting with them. I will assume that you have never painted and will therefore begin with the most basic instruction: what materials to buy, how to set yourself up to work, how to hold a brush, how to arrange hues on a palette, what kind of paper to use, how to mix colors, even how to clean your brushes. Then, starting with the simplest exercise—painting a color wheel—you will begin using the color vocabulary to help you in mixing colors. You will learn to see colors accurately, to mix them, and to combine them to achieve beautiful color compositions.

Buying Supplies

Paints

Art supply stores can be a bit daunting. Art materials are numerous, complicated, and variable in price and quality. I have kept the materials needed for the exercises that follow as simple and inexpensive as possible. I recommend acrylic paints over oils, watercolors, gouache, or poster paints, although any of these can be substituted if you happen already to have them. Acrylics are relatively reliable, widely available, inexpensive, nontoxic, and—unlike oil paints—are mixed with water. Acrylic colors become slightly darker when they dry, but other paint mediums have different problems and are somewhat more difficult to work with. You can buy acrylics in small bottles (two ounces or four ounces) or in tubes; the pigment quality and the cost are about the same. Bottled pigments are slightly easier to handle, since they are ready for painting and do not need to be thinned with water. However, tube pigments are more widely available. I recommend that you buy pigments designated "artist quality" rather than "student quality," because the former have a greater proportion of pigment to binder and are therefore "stronger" in mixtures.

You will find dozens—maybe hundreds —of hues in acrylic pigments, but you will need only nine:

- Titanium white
- Ivory black
- Cadmium yellow pale
- Cadmium orange
- Cadmium red medium
- Alizarin crimson
- Cobalt violet
- Ultramarine blue
- Permanent green

As an alternative to acrylic paints, you may wish to try the new water-based oil paints. Though not quite as readily available as acrylic pigments, they combine some of the good qualities of oil pigments with the nontoxicity of water-based acrylics.

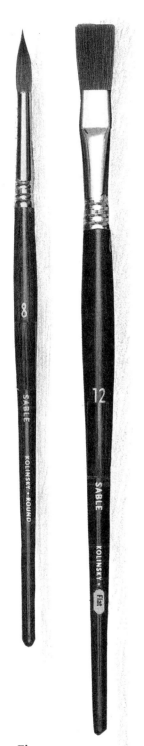

Fig 4-1.

Try not to accept any substitutes for these nine specific pigments, and do not be tempted by the array of luscious colors. Color manufacturers use a similar limited set of basic pigments to mix up most of those beautiful (and expensive) hues with exotic names like Lagoon Blue, Samarkand Gold, and Ashes-of-Roses. I promise: with the pigments listed above, you will be able to mix almost any hue.

In time, you probably will want to add other pigments to your palette; there are many beautiful and useful colors. For now, while you are learning the basics of color, buying more pigments may only make you dependent on manufactured colors. Later, you will know how to decide which pigments are truly helpful (those that have unique qualities or are difficult to mix from the traditional palette) and which are superfluous (those you can easily and more inexpensively mix yourself).

The "pigment problem" that confronts everyone who wants to learn about color is that the available pigments are often inadequate in terms of color clarity, and this has always been a problem for artists. Nevertheless, mixing actual pigments is the best way to understand the basics of color. Color is complicated, and, as my students have found after trying to understand color by first pasting precolored chips of paper, the actual process of mixing pigments is an entirely different and far more complex experience. You surely could work through the difficulties for yourself, without instruction, but you might mix and discard buckets of paint in the process.

Brushes

Brushes are sorted by number and by type. You will need two watercolor brushes: a #8 watercolor round and a #12 watercolor flat, which is about ½ inch wide (Figure 4-1). You will use the #8 round brush for most of the following exercises; the #12 flat will be useful for painting large areas. Watercolor brushes have shorter handles than oil brushes

because they are held differently. An artist using oil paints usually works sitting or standing in front of an easel, which holds the canvas in upright position, and a long brush is held rather far back on the handle to accommodate this upright stance (Figure 4-2).

Watercolor brushes are held closer to the *ferrule* (the metal binding of the brush hairs) and, for balance, are shorter. You will not need an easel for the exercises in this book as you will work flat on a table or, at most, on a slanted drawing board, and the long brushes are out of balance when working on a flat surface—like trying to write or draw with a fourteen-inch-long pencil. I mention this because in the past, some of my students have mistakenly bought long brushes thinking, as they told me, that bigger must be better.

I urge you to buy the best brushes you can afford, because good brushes last a very long time and cheap brushes do not. Sable brushes are the best, but some of the synthetic brushes are quite good and are less expensive. You know you have a good brush if, after it has been thoroughly dipped in water, it reshapes itself to a sharp point, or, if it is a flat brush, it forms a sharp edge.

Fig. 4-2. Sketch by the author after a photograph of Winston Churchill painting in oils. From *Painting as a Pastime* by Winston Churchill, 1950.

Painting Surface

The best surface for the exercises in this book is white, cold-press illustration board, which is widely available and relatively inexpensive. You will need twelve 9" × 12" pieces and one 10" × 10" square piece. You can have them cut at an art supply store or you can sometimes find them already cut to size.

Palette

A palette is any flat surface on which you mix paints before applying them to canvas or paper. Art supply stores carry a wide selection of white plastic palettes in a variety of shapes, all of them useful. Buy one that has a fairly large mixing surface as well as compartments to hold individual

pigments. Some palettes come with lids that you can use both as an extra mixing surface and as a lid to help preserve leftover pigments overnight. If you can find one, an ordinary butcher's white porcelain-on-metal tray makes an excellent palette that is easier to clean than plastic. Simpler yet is a white ceramic dinner plate—also easier to clean than plastic, though somewhat restricted in size and possibly breakable. A nylon mesh kitchen scrubbing pad is useful for removing dried paint from your palette.

Miscellaneous Materials

For the exercises, you will need the following materials:

- A 9" × 12" piece of heavyweight paper, such as bristol board or tagboard, for cutting a template for the various wheels used in the exercises.
- A small mat knife to cut the template.
- A small metal or plastic palette knife for dipping out and mixing pigments.
- A few sheets of graphite paper (the modern version of carbon paper) to be used for transferring designs to illustration board.
- One or two containers, at least pint-sized, to hold water for mixing hues and for cleaning brushes. Large coffee cans are useful as are plastic containers.
- Paper towels or clean rags are always useful.
- A roll of ¾-inch-wide low-tack masking tape, sometimes called "artist's tape."
- A pencil and eraser, and a ruler.
- A table to work on, or a drawing board that can be leaned against a table edge.
- A special lightbulb that simulates natural light, which you should be able to find at a hardware store or home improvement center. If you need to work in the evening or in a dimly lighted indoor space during the day, this kind of bulb is a good investment.

- An old shirt to wear—not a bright color, however, which might reflect color onto your work, thus distorting your perception of hues.
- A pack of colored construction paper, 12" × 14" or larger, with a mix of colors.
- A piece of clear plastic or acetate, 9" × 12" × $\frac{1}{16}$" (or $\frac{1}{8}$").

Beginning to Paint

Setting Up

For painting, the ideal situation is to have a permanent corner or table where you can leave your materials set up for work. If that isn't possible, arrange for a place to store your painting supplies, and try to work in the same spot each time. In this way, setting up to paint becomes routine and rapid. People have individual preferences for setting up, but here are a few suggestions:

- You should place your palette, brushes, and water containers on the side of your dominant hand, right or left, to avoid reaching across a wet painting. If you are ambidextrous, try either side to find which is most comfortable.
- Keep all of your pigment bottles or tubes close by, as well as paper towels or clean rags, your pencil, eraser, and ruler, and the illustration board you plan to work on. You want to minimize any interruptions to *R-mode*, such as having to get up to retrieve a missing pigment bottle. Mixing colors is disruptive enough!
- Use masking tape or low-tack "artist's tape" to tape your illustration board to your table or drawing board. This prevents the board from slipping around as you paint on it. (You will also use low-tack tape to make an automatic border around your work. Once you have completed your painting, you will remove the tape.)

Fig. 4-3. Sketches of their palettes by Vincent van Gogh (top) and Henri Matisse (bottom). Van Gogh's 1882 drawing shows nine colors, and Matisse's 1937 sketch shows seventeen colors, with large mounds of white in the center.

- Keep on hand some scraps of white paper or leftover pieces of illustration board to test colors.

Arranging Your Palette

Every painter has a special way to "set a palette," that is, to arrange pigments on the palette. In time, you will find your own favorite ordering of colors (Figure 4-3). For now, I recommend the following arrangement of your nine pigments.

Along the top edge of your palette, squeeze from your pigment tubes or dip out with your palette knife from your pigment bottles about a half to a full teaspoon of pigment into each compartment, in this order, from left to right (or vice versa for left-handers) (Figure 4-4):

- Cadmium yellow pale
- Cadmium orange
- Cadmium red medium
- Alizarin crimson
- Cobalt violet
- Ultramarine blue
- Permanent green
- White
- Black

Place the white and black pigments slightly away from the colors, and leave the central area of your palette clear for mixing colors.

Holding the Brush

My first instruction on holding a brush is the most important and applies to all painting mediums and all brushes. Hold a paintbrush *firmly* (although that doesn't mean squeezing so hard that your fingers tire quickly). Many beginners hold a brush too lightly, allowing it to flutter around as the brush hairs move across a surface. The best position for your hand and fingers is shown in Figure 4-5. As you see, the fingers are more extended than

Fig. 4-4. Palette.

About 1912, Russian artist
Wassily Kandinsky wrote:

"Letting one's eyes wander over
a palette laid out with colours has
two main results:

"(1) There occurs a purely physi-
cal effect, i.e. the eye itself is
charmed by the beauty and other
qualities of the color. The spec-
tator experiences a feeling of
satisfaction, of pleasure, like a
gourmet who has a tasty morsel
in his mouth...

"(2) The second main consequence
of the contemplation of color, i.e.
the psychological effect of color.
The psychological power of color
becomes apparent, calling forth a
vibration from the soul..."

Kandinsky, *Complete Writings
on Art*, 1982

when using a pencil. Ideally, the forearm, wrist, hand,
fingers, and brush become one, with the brush an exten-
sion of the hand. For this reason, it is best, when possible,
to rest your elbow on your board or table instead of your
wrist as in writing. Painting very small or detailed areas is
the exception—in those cases, rest your wrist on the table.

The brush is mainly held between the thumb, the
forefinger, and the middle finger, with the thumb and
forefinger placed about where the ferrule meets the wood of
the handle (Figure 4-5). "Choking up" on the brush (holding
it too close to the brush hairs) makes painting very difficult.
It's hard to see what the brush is doing, and your ring finger
and little finger get in the way. When a brush is properly

Fig. 4-5. Holding the brush
properly.

Fig. 4-6. Using the little finger to guide the brush.

Fig. 4-7. Try mixing pigments to match this color.

held, the little finger can be used to rest on the painting surface and guide your brush stroke (Figure 4-6).

You can practice working with your brushes by painting with just tap water on newspapers. Practice short strokes, long strokes, broad strokes, and narrow strokes, marks made with the brush fully loaded with water, and those made with "dry brush" where you squeeze most of the water from the brush with your fingers or with a paper towel, producing a textured "dry" stroke.

Mixing a Color

Now that you have all of your supplies in place, you are ready to begin experimenting with mixing colors. Let's start by creating a light, bright yellow-orange similar to the hue shown in Figure 4-7.

1. Set up your palette as described on page 42.
2. With the tip of your round brush or with your palette knife, pick up some white pigment and take it to the center of your palette, spreading it a little. Then, with the same brush and without rinsing it in water, pick up a bit of cadmium yellow pale. Deposit it to one side of the white, then pick up and deposit a *tiny* amount of cadmium orange, a bit away from the yellow. You will find that the pure colors on your palette are very strong and a very small amount can tint a large amount of white.
3. Gradually mix some of the yellow into the white, and then carefully add some orange, adding a bit at a time until the hue looks right to you—that is, neither too yellow nor too orange. You may need to thin the paint a little by adding water, even though bottled pigments are already thinned. Dip just the *tip* of your brush in water and mix it into the paint. Remember, you can always add more water but you can't remove it. The paint should be thick enough to

cover the white of a piece of paper but thin enough to brush on smoothly.

4. Now, test the hue by painting a swatch on the edge of a scrap of paper, letting it dry a bit, and comparing it to the hue in Figure 4-7. If either the orange or the yellow seems too dominant, adjust the color by adding pure pigment until you have a true match to the pale yellow-orange. If you were working on a painting, you would hold the test swatch near your painting to check the correctness of the color and adjust the hue if necessary.

Exercise 1. Subjective Color

Part of the joy of painting lies in finding out how you feel about color. Each of us has color preferences that are rooted in personal experience, physiology, and psychology. The following exercises, based on the teaching of German colorist Johannes Itten, will help you learn where your preferences lie. For these exercises, you will need two 9" × 12" pieces of illustration board.

Part I

1. On the first board, draw two 4" × 4" squares (called "formats"), using pencil and a ruler. (You may prefer a larger-sized format. If so, use one piece of board for each and draw 7" × 7" formats.)

2. Apply masking tape or low-tack "artist's tape" around the four edges of each format. See Figure 4-8. This will enable you to paint right up to the edge of each format if you wish, and when you remove the tape, you will have a crisp edge to your paintings.

3. Using pencil, print or write the title "Colors I Like" on the tape under one format, and under the other "Colors I Dislike."

4. Without thinking about it in advance, begin to choose colors from your palette. Do not hesitate to

A format is the outlined shape within which a drawing, painting, or design is composed.

COLORS I LIKE

COLORS I DISLIKE

Fig. 4-8. Using tape to mask the edges of the formats.

mix colors freely, and paint them within the "Colors I Like" format. This small painting is strictly a color statement. Do not portray any recognizable objects, signs, or symbols whatsoever. Stop when you are satisfied that you have expressed the colors you like.

5. Now, mix colors to paint within the "Colors I Dislike" format, again without portraying any recognizable objects, signs, or symbols. Stop when you feel that the colors have expressed your intent.

6. Carefully remove the tape from around each format and retitle each drawing.

With pencil, sign and date your work and set it aside for now.

Part II

1. See Figure 4.9. On the second piece of illustration board, draw four 3½" × 3½" formats, using pencil and a ruler. In these formats, you will paint the colors that to you express the four seasons of the year.

2. Use low-tack tape on the edges of each format.

3. *On the tape* under each format, print or write in pencil the seasons' names—spring, summer, fall, and winter (Figure 4-9). Use pencil to divide the formats into sections if you wish, or start painting directly within each format.

4. In your mind's eye, visualize each season in turn. Without portraying any recognizable objects at all, mix and paint colors to show what each season signifies to you.

5. Carefully remove the tape, which also removes the names of the seasons. As an experiment, ask someone if he or she can discern which painting represents each season. You may be surprised at the ease with which the person "reads" the meaning of the colors.

You will find some student examples of "Colors I Like," "Colors I Dislike," and of the four seasons on pages 159 and 160. You may prefer to not look at them until you have completed your own paintings.

Fig. 4-9. Four seasons.

Using your pencil, retitle each painting with the seasons' names. Sign and date your painting, and set it aside for now.

These small paintings are a first step in a long process of self-discovery through color that you will experience as you acquire knowledge about the amazing world of color. As in all artwork, the goal is to find yourself—*your* style in color, *your* expression, and *your* unique sensibility. You have made a first statement.

Cleaning Up

At the end of each painting session, you will need to clean and store your brushes. Practice this now by rinsing your brushes *thoroughly* under clean running water. Work residual paint from the brush hairs with your fingers. When the water runs clear, press excess water from the brush and shape it to a point (or to an edge for your flat brush). Then stand it upright, with the brush end up in an empty glass (Figure 4-10). Never—I repeat, *never*—leave a paintbrush with its brush end sitting in water. It ruins the brush by permanently bending the bristles.

Clean your palette by wiping the mixing areas clean with damp paper towels. To preserve as much leftover paint as possible, use your brush to put a few drops of water on each pigment and, if your palette has a lid, close it tightly. If you are using a butcher's tray or a ceramic plate, cover the pigments with clear plastic wrap, or, if you prefer to start each day with a clean palette, wipe off the remaining paint with paper towels and wash your palette. (Note: Acrylics are nontoxic to the environment.)

Now that you have your painting materials and have begun to become acquainted with their use, the next step is to put the color wheel hues into long-term memory by painting a color wheel. In chapter 5, I will teach you how to make your own color wheel and provide several experiments to help

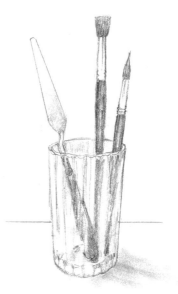

Fig. 4-10.

CHAPTER 5

Using the Color Wheel to Understand Hue

J UST AS LEARNING the ABC's is the prerequisite for reading and understanding the words on this page, the color wheel is prerequisite to using and understanding color. Artists take the wheel very seriously, as did all those great thinkers of the past who labored to understand color and to place colors into a usable structure. Now that you have absorbed the vocabulary of color, constructing a color wheel will make the vocabulary concrete, and then we can move on to manipulating the values and intensities of colors and to creating harmonious compositions.

You will refer to your color wheel constantly, because every mixture begins with the question: What is the basic source color for this hue? The answer to that question is one of the twelve color wheel hues. On your palette, however, you have only the primary colors and the secondary colors. Constructing a color wheel will teach you how

to quickly mix the tertiary colors. At the same time, you will learn how to compensate for the limitations of our primary pigments, thus opening the whole world of color mixing.

Exercise 2. Making a Color Wheel Template

Your first step is to make a color wheel template. This template will make it easy for you to set up the wheels you will paint for various exercises in understanding color.

1. Figure 5.1 is a pattern for a color wheel template shown enlarged on page 50. Photocopy this large pattern directly onto a heavy sheet of paper—bristol board, tagboard, or cover stock. If you prefer, you can use graphite paper to trace and transfer the wheel template to card stock. Use your small mat knife to cut out the narrow spaces indicated on the template.
2. Next, use scissors to cut the outside circular edge of the template.
3. To use the template, simply mark the openings onto illustration board with a very sharp pencil and, working freehand, connect the lines to finish the pattern (Figure 5-2). If you prefer, you could photocopy the finished pattern onto a dozen sheets of cover stock.
4. Notice that there are twelve hues, arranged like the numbers on the face of a clock. In pencil, very lightly mark the hour numbers on the clock/color wheel (Figure 5-2). As we progress through the exercises, this familiar image of a clock face will help you in visualizing and memorizing the color wheel.
5. To reinforce the use of this clock-mnemonic, we will place the warm colors (yellow through red-violet) on the right-hand side in the "daylight hours," 12 o'clock (as in 12 noon) to 5 o'clock, and the cool colors of the "evening hours" (violet through yellow-green) on the left-hand side, from 6 o'clock to 11

Fig. 5-1. Color wheel template. See page 50 for the enlarged version.

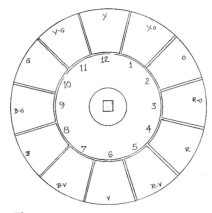

Fig. 5-2.

o'clock. In pencil, lightly mark the first letters of each hue at the appropriate segment on the wheel (Figure 5-2).

Note that you have only seven pigments on your palette (ignoring, for a moment, black and white) to make the twelve fundamental *spectrum* colors of the wheel. You will need to mix the rest. Let's get started.

Exercise 3. Painting the Color Wheel

Arrange your painting materials and set up your palette as instructed on pages 41 and 42.

1. First, paint the three primary colors as in Figure 5-3.
 Yellow: At 12 o'clock on your clock/color wheel, use your #8 round brush to paint pure cadmium yellow pale straight from the tube or jar, thinning the paint only if necessary. Cadmium yellow pale is very close to true spectrum yellow and is the purest and brightest yellow available in pigments.
 Red: Clean your brush well and paint cadmium red medium at 4 o'clock on the wheel. Cadmium red medium is fairly close to a true spectrum red. This pigment slightly reflects red-orange wavelengths, but is the best we have to use as our spectrum red.
 Blue: Once more, clean your brush well. Use your ultramarine blue to paint spectrum blue at 8 o'clock. Ultramarine blue is fairly close to the pure spectrum hue (it reflects a slightly blue-violet wavelength).

2. Using your pencil, connect the three primary colors with an equilateral triangle within the circle, as shown in Figure 5-3.

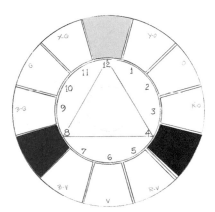

Fig. 5-3.

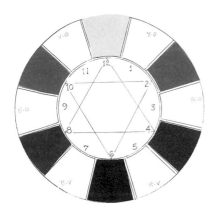

Fig. 5-4. Notice that the primary and secondary colors fall on the even numbers on the clock face.

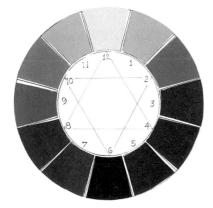

Fig. 5-5.

3. Next, paint the three secondary colors as in Figure 5-4.

Orange: Paint cadmium orange at 2 o'clock on your color wheel. Cadmium orange is the brightest, clearest orange available and is a true spectrum hue. You could mix orange from cadmium yellow pale and cadmium red medium, but the resulting mixture is not as brilliant as the cadmium orange pigment. The reason is that any mixture of pigments will be duller than chemically purer single pigments.

Violet: Paint cobalt violet at 6 o'clock. Cobalt violet is a fairly good match for the spectrum hue. Again, you should be able to mix violet from cadmium red and ultramarine blue, but the limitations of our red pigment produces a muddy violet.

Green: Paint permanent green at 10 o'clock. Permanent green is fairly close to a clear spectrum green.

Recall that the three secondary hues also form an inverted equilateral triangle, which, together with the primary triangle, forms a six-sided star. Use your pencil to connect the secondary hues (Figure 5-4). These geometric connections will help you to memorize the location of the color wheel primaries and secondaries. As you will see, each tertiary color will come between two points of this six-sided star.

4. Last, mix and paint the six tertiary colors as in Figure 5-5 (see page 53 for an enlarged completed wheel).

Yellow-orange at 1 o'clock: Mix this spectrum color using cadmium yellow pale and cadmium orange. Paint a test swatch on a bit of scrap paper and wait a few moments to let it dry. Recall that acrylic paints dry slightly darker than the color you see when the paint is wet. You want to make sure that your yellow-orange, when dry, is *midway in hue* between yellow at 12 o'clock and orange at 2 o'clock— that is, neither too yellow nor too orange, but just in

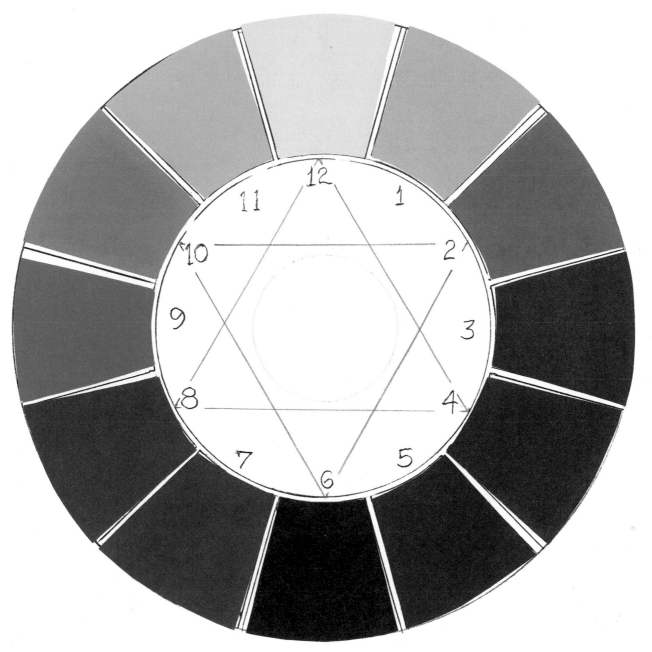

Fig. 5-6. Notice that the tertiary colors fall on the odd numbers of the clock face.

between. To get this right, you need to "eyeball" the three hues—yellow, yellow-orange, and orange—to judge the rightness of your yellow-orange mixture. Eyeballing means to look intently at the three hues to judge the rightness of their relationship.

Beginners tend to be very good at making these judgments. Your eye will tell you and you can trust your judgment. What is difficult is forcing yourself to remix, retest, and repaint if the first (or second, third, or fourth) mixture is "off-hue"—in this case, too yellow or too orange. When you are satisfied with your yellow-orange mixture, add it to your color wheel at 1 o'clock.

Red-orange at 3 o'clock: Mix some cadmium red into cadmium orange. Again, test-paint and let dry, then eyeball your mixture to make sure that your red-orange is midway between orange at 2 o'clock and red at 4 o'clock. When it is right, add red-orange to your wheel at 3 o'clock.

Red-violet at 5 o'clock: With this tertiary hue, we begin to delve more deeply into mixing colors. Theoretically, you should be able to use the spectrum red you painted at 4 o'clock plus cobalt violet at 6 o'clock to achieve red-violet. The pigment cadmium red, however, which we are using for our spectrum red, tends toward orange. This slightly orange color of red, when mixed with cobalt violet, produces a dull and muddy red-violet, not the bright spectrum red-violet you need for your wheel. Note that conversely our alternate red, alizarin crimson, when mixed with orange will not yield a clear red-orange. The blue tendency of alizarin crimson will dull the red-orange. You might try both mixtures to see for yourself.

Instead of cadmium red, therefore, you must add *alizarin crimson* to your cobalt violet to achieve a clear spectrum red-violet. This is why you need *two* reds for your palette. No reliable, readily available red is pure enough to mix well with yellow on one side of red (to make orange and red-orange) and blue on the other (to make violet and red-violet). When you have mixed a clear red-violet midway

"Not until the 1920's did he [Dutch artist Piet Mondrian] seek a categorically 'pure' red, and found, as had so many painters before him, that he could only achieve his aim by glazing a bluish transparent pigment such as crimson over an opaque orange-red, such as vermilion."

E. A. Carmean, *Mondrian: The Diamond Compositions,* **1979**

between red at 4 o'clock and violet at 6 o'clock, paint it into your color wheel at 5 o'clock.

Blue-violet at 7 o'clock: Mix this hue by adding cobalt violet to ultramarine blue. Before painting the segment at 7 o'clock, check that your mixture is midway between violet and blue.

Blue-green at 9 o'clock: Start with permanent green and add ultramarine blue, again checking that your blue-green is midway between blue and green at 8 and 10 o'clock.

Yellow-green at 11 o'clock: Start with cadmium yellow and carefully add permanent green. Permanent green is a "strong" pigment; you will need only a little to achieve a hue midway between the secondary green at 10 o'clock and the primary yellow at 12 o'clock.

5. Now that you have painted all of the spectral hues, carefully redraw and darken the numbers on the wheel with pencil to complete the clock-face mnemonic (Figure 5-5). As you see, the moment both the numbers and the twelve colors are in place, it becomes instantly easier to determine comple- ments (two hues directly opposite each other) and analogous hues (three, four, or, at most, five hues lying next to each other on the wheel), and to com- prehend these relationships.

6. To put your color wheel into permanent, long-term memory, gaze at your painting intently, as though you are taking a mental photograph. See the wheel as a colored clock face. Next, close your eyes and try to "see" the wheel in your mind's eye. At what o'clock is orange located? What color is opposite orange (the complement of orange)? At what o'clock is it located? What color is between red-violet and blue-violet? What is the complement of green? At what o'clock is it located?

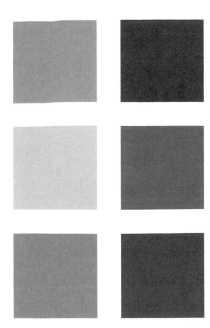

Fig. 5-7. Which color wheel hue is the source of each of these colors? Key on page 58.

If possible, place your color wheel where you can see it frequently during the day and practice memorizing it. Proficiency in color mixing requires knowing the color wheel by heart. To reiterate, the wheel may seem simple—even simplistic—but, as every artist knows, it is not.

Exercise 4. Practice in Identifying Hues

1. Figure 5-7 is a set of six colors. For each color, decide which of the twelve color wheel hues is the source hue for the color. Try to do this by visualizing your memorized color wheel. (If necessary, consult the wheel on page 24.)
2. Find a bright-colored object among your surroundings, and name the source hue of that color.
3. Find a dull color among the objects around you. Ignoring the lightness or darkness and the brightness or dullness of the color, can you name the source hue?
4. Find two objects of very pale color—almost white, but not pure white. Do these objects have the same or different source hue?
5. Find two very dark objects—almost black, but not pure black. Do they have the same source hue?
6. Find two objects made of wood. What are the source hues of these colors?

As you go through the day, pause to practice this new skill of identifying color wheel source hues of colors you encounter. Each practice in naming takes only a moment, and you will find that it quickly becomes easy. A bonus of this practice is that you will be truly seeing more colors, and seeing them from a new point of view.

Mixing Colors

In the process of constructing this color wheel, you have mastered the basis of color's first attribute: hue. By memorizing the color wheel, you will be able to identify the source hue of any color you see, no matter how subtle the color—say, a piece of driftwood or the sky at dawn—and you will know the complement of that hue. You know also that the hues you have painted on your color wheel are the most brilliant hues you can achieve with pigments. For each of the twelve spectrum colors, there is no way of making the colors brighter. *Every addition to every spectrum hue will diminish the brilliance of the hue.*

Now that you understand that the first step in mixing colors is to identify the color wheel source hue, you can see why fashion color names (for example, lime, saffron, fuchsia, turquoise, coral, navy, tobacco, goldenrod, robin's-egg blue, and so on), though they can provide metaphorical mental images of colors, are not helpful in mixing colors. Even colors that we may casually call black and white are often very dark or very light values of one of the twelve basic hues. In the next two chapters, we'll take up the remaining two attributes: value (how to lighten and darken colors) and intensity (how to manipulate brightness and dullness of colors).

Creating Colors: How Four Pigments Can Become Hundreds of Colors

By manipulating the three attributes of a very small set of pigments, you can mix potentially hundreds, even thousands, of hues. For example, you could start with four pigments: permanent green, white, black, and cadmium red. Beginning with permanent green, we know that that pigment, right out of the tube or bottle, is already the brightest (most intense) it can be. Nothing you can add will make it brighter. Its *value*, however, can be lightened to make hun-

One of my fellow art teachers, Professor Doreen Gehry Nelson, having delivered a lecture on color, asked if anyone in the class had a question.

One student asked, "From your lecture, I gather that you like color very much. Why, then, do you always wear black?"

Professor Nelson answered, "Ah, but what color of black?"

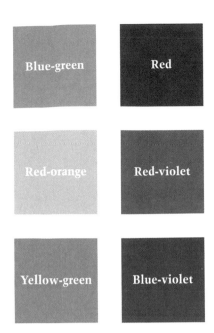

Key to Figure 5-7.

dreds of new hues by incrementally adding white, *and* its value can be darkened to make hundreds of additional new hues by incrementally adding black. Permanent green, mixed first with white and then black, can go from the palest clear green to green so dark it is almost black. In addition (and this is where the proliferation of colors begins to boggle the mind), each of those *value-changed* hues can be incrementally dulled (*intensity-changed*) from bright green to no color, that is, to no discernible color, by adding its complement, cadmium red, thus *doubling* the number of hues (Figure 5-8).

Now consider this: You can *again double* the hundreds of hues achieved above by using the same set of four pigments to go through the same process, this time using cadmium red as the source color. You would first add white to red, and then add black to red to change the values from palest pink to a near-black red. Then you would use green to dull the intensity of each value-changed, red-based hue. Figure 5-8 shows only a fraction of the colors you can derive from red, green, black, and white.

By thinking of colors in this way, you arrive at some sense of the enormous number of hues—sixteen million or more—at your command with our limited palette of only seven pigments plus white and black. The key to *accessing* this tremendous storehouse of color, of course, is the knowledge you are gaining of how to see, identify, and mix a perceived hue—or, put another way, knowing what color you need and how to achieve it.

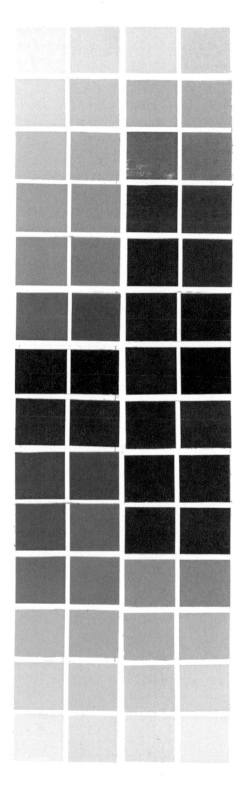

Fig. 5-8.

Using the Color Wheel to Understand Value

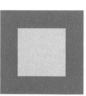

Fig. 6-1.

EVERYTHING ABOUT COLOR has to do with relationships, and the questions you need to ask in order to understand color are all about relationships. In this chapter, we take up how to see colors as *values relative to a gray scale*. This skill is essential for deciding how light or dark to make a color.

Perceptions of relationships are the province of the right hemisphere of the brain. In my experience, I have found that students can easily assess differences between two similar hues placed side by side, for example, which of two colors is bluer and which is greener—no problem there! Problems arise, however, in assessing *value* levels of an *individual* hue when that hue is put into context with several different colors. Figure 6-1 shows how the same yellow can seem lighter or darker depending on the surrounding hue. Even when you *know* that the yellows are the same, it is still hard to believe it because of the

complications of simultaneous contrast and other brain-related misperceptions.

Value

The best way to assess accurately the lightness or darkness of a color is to construct a gray scale that can also be used as a tool to gauge the value levels of specific colors. As with Newton's color wheel, we are going to "roll up" our gray scale into a value wheel. Values are traditionally shown arranged in a linear scale from white to black, as in Figure 6-2. Circular scales, however, are much easier to see in the mind's eye, therefore making it easier to visualize *opposite* values, which are important in harmonizing color. Therefore, we will again use the clock face as our mnemonic for identifying the value levels of colors (Figure 6-3).

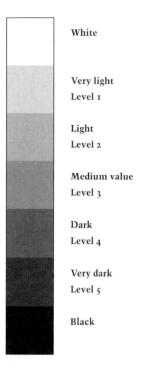

White

Very light
Level 1

Light
Level 2

Medium value
Level 3

Dark
Level 4

Very dark
Level 5

Black

Fig. 6-2.

Exercise 5. Shades of Gray— Constructing a Value Wheel/Hue Scanner

1. Use your template to draw a wheel on a 9" × 12" piece of illustration board. This time, cut out the wheel from the board by cutting along the outside rim of the circle with your mat knife or scissors. With your mat knife, cut out the small square in the center of the wheel.

2. Set up your palette with white and black pigments only. Paint the 12 o'clock segment with pure white, making sure that you paint right up to the circular edge, or, better still, *off* the edge, of the wheel.

3. Next, paint the 6 o'clock segment with pure black.

4. Mix white and black to achieve a gray that is just midway between white and black. Eyeball your mixture to make sure it is middle value gray, and then paint the 3 o'clock segment. (Save the mixture on your palette because you will use it again on the way up from black to white, from 6 to 11 o'clock.)

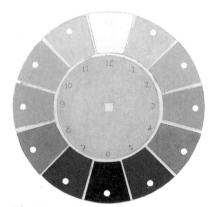

Fig. 6-3.

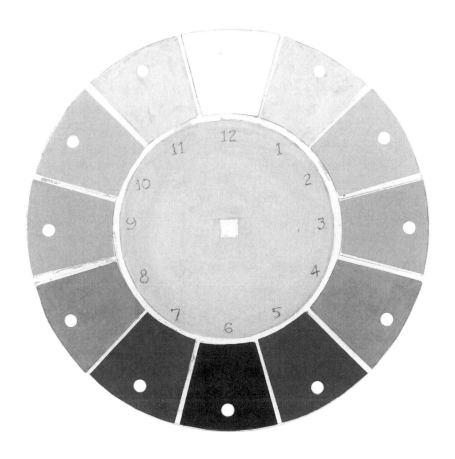

5. Now add white to your middle value gray to "step up," or lighten, the value in equal increments at 2 and 1 o'clock, going toward white at 12 o'clock (see the value wheel above). Paint these segments and eyeball the values again to make sure that you have equal steps up from middle value gray at 3 o'clock up to white at 12 o'clock. Again, save the mixtures.

6. Next, mix two grays that "step down," or darken, in value by adding black to your middle value gray. Paint these darker grays at 4 o'clock and 5 o'clock, again making sure the steps between middle value and black are equal steps.

One-half of your value wheel clock face is now complete. Check to make sure you have equal steps from white to black by squinting your eyes to see if there is an even flow of steps from white to black. If any level seems too dark or too light, adjust the mixtures and repaint if necessary.

7. Using the gray mixtures already on your palette, complete the clock face by painting 7, 8, 9, 10, and 11 o'clock on your value wheel, this time "stepping up" from black to white. Middle value gray will again appear at 9 o'clock.

a. Paint the large inner circle of the wheel a pale gray— a value just between level 1 (very light) and level 2 (light). You will use this central area with its small cutout square as a hue scanner, as I explain below.

b. The last step is to use a hole punch to make a hole in each value step from 1 to 12 o'clock and to print the clock-face numbers on the wheel, using either pencil or pen. See the completed value wheel on page 62.

How to Use Your Value Wheel/Hue Scanner

You will use this wheel in three ways:

- First, as a *hue scanner* to name the source hue of a color, its first attribute.
- Second, as a *value finder* to name the color's second attribute, its lightness or darkness.
- Third, as an *opposite-value finder* for one of the exercises to come. The arrangement of values on the wheel—from white to black and then, in reverse order, from black to white—makes finding opposites very easy.

Fig. 6-4. Use the square center to determine the source hue.

Fig. 6-5. Use the outer punched holes to determine the value level.

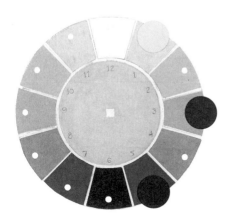

Fig. 6-6.

For now, practice using your value wheel/hue scanner by doing the following:

1. Hold up the wheel at about arm's length, close one eye, and look at a color in the room through the square hue scanner opening in the center of the wheel (Figure 6-4).
2. Name the source hue of the color—one of the twelve color wheel hues.
3. Then, look at the same color through the punched holes of the gray scale, turning the wheel to compare the color to several values in your gray scale until you find the value that "fits" the color (Figure 6-5).
4. Name the value level according to its clock number 12 to 6. Note that the wheel also enables you to find the opposite value (6 to 12). For example, the opposite of value level 2 is value level 8.

With the help of this tool, you have thus named the first two attributes of color (hue and value) as preparation for mixing it (leaving the third attribute—intensity level—still to be determined, a skill you will learn in chapter 7). The next step in your exploration of value is to learn how to make colors lighter or darker.

How to Lighten and Darken Colors

Each pure pigment that you buy in tubes or jars has its own value level. Cadmium yellow pale, for example, is at about value level 1 on your value wheel, whereas cadmium red is about midvalue or value level 3, and cobalt violet is inherently darker at about value level 5 (Figure 6-6). Each of these pure colors can be made lighter or darker by adding either white or black, but each pure pigment will react differently to these additions, depending on the inherent value level of each pigment. For example, to lighten yellow to almost white, only a small amount of added white is

needed. To lighten cobalt violet to almost white, however, requires a much greater amount of white. Similarly, to darken yellow to almost black requires a great deal of black (this mixture actually results in a dark greenish black), but to darken cobalt violet to almost black requires very little black pigment.

The following exercise will give you excellent practice in seeing the results of incrementally adding white or black to pure colors. You will create two wheels: in the first, you will take a color from white at 12 o'clock to the pure color at 6 o'clock, and then from the pure color back up to white on the left side of the clock; in the second wheel, you will take the same pure color at 12 o'clock to black at 6 o'clock. Figure 6-7, pages 66 and 67, shows two color value wheels for the primary pigment *ultramarine blue*.

Exercise 6. Two Color Value Wheels—From White to a Pure Hue, From a Pure Hue to Black

Part I. *Using White to Lighten Colors*

1. Use your template again, this time to make two wheels on two 9" × 12" pieces of illustration board. In tracing the template, omit the central circle and the small, central hue scanner square.

2. Choose one of the twelve spectrum hues and set up your palette with white, black, and your chosen hue. On the first wheel, paint the 12 o'clock segment with white and the 6 o'clock segment with the pure hue.

3. Starting with white, mix even steps in value from 1 to 6 o'clock by adding progressively more pure hue to white. Save each mixture to use in completing the left side of your wheel. Once you have arrived at the pure color at 6 o'clock, check that you have *even steps*. If not, revise the mixtures and repaint as needed.

Each time you work for even steps in these wheels, you are training your eye to perceive small but significant differences in hues.

Fine discrimination in *relationships of colors* is at the heart of color expertise. As an artist friend, Don Dame, once said to me, "Color is *all* relationship."

Fig. 6-7. Two value wheels for the pigment ultramarine blue. The first wheel goes from white at 12 o'clock to pure blue at 6 o'clock. The wheel opposite goes from pure blue at 12 o'clock to black at 6 o'clock.

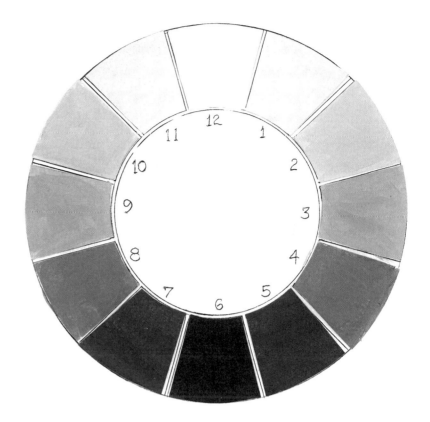

4. Use your set of mixed hues to complete the circle from 7 o'clock back up to 12 o'clock.
5. Use a pencil or pen to number carefully your color value steps with the clock-face numbers of 1 to 12.

Part II. Using Black to Darken Colors

1. Start your second wheel by painting the same pure hue at 12 o'clock and painting black at 6 o'clock.
2. Begin to mix black pigment bit by bit into the pure hue, lowering its value in even steps from 1 o'clock to 6 o'clock.
3. Save your mixtures, remix and repaint if necessary to make even steps, and complete the wheel from black at 6 o'clock to white at 12 o'clock.
4. Add the clock-face numbers 1 to 12 in pencil or pen.

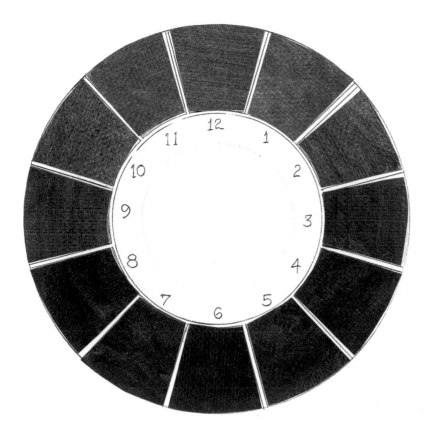

As you see, these wheels are quite elegant, and they are extremely useful as well. The numbered values enable you to determine easily the *opposite value* for any given hue. This is important because harmonious color often includes hues of the same color and intensity but *opposite* values. Imagine the two hands of the clock locked into a straight line as in Figure 6-8. By mentally rotating the hands, you can see in your mind's eye the two opposite values. For example, value levels 1 and 7 are opposites, as are 2 and 8, 3 and 9, 4 and 10, 5 and 11, 6 and 12.

Time permitting, it would be enormously helpful to make color value wheels for other hues. You would then learn, for example, that because pure violet is inherently quite dark, mixing in six steps from pure violet to black requires very small, incremental steps, while lightening violet in six steps to white requires large changes at every

Fig. 6-8. The hands of the clock show *opposite values*.

step. Additionally, you would have the experience of seeing what happens to orange and what happens to yellow when black is added (orange turns brown and yellow turns olive green). Obviously, the more you work with color, the greater your knowledge will be of what happens to pigments in mixtures, and the larger your repertoire of color mixtures will become.

Other Ways of Lightening and Darkening Colors

To lighten colors—that is, to raise their values—you will nearly always use white. However, there are also some other ways to lighten a color. For example, rather than using acrylics as an opaque medium like oils, you can use them as a transparent medium similar to watercolor by adding water to thin the paint. This lightens a color by allowing the white of the paper to show through. Another way to lighten colors is to add one of the paler color wheel hues—cadmium yellow pale, for example—to one of the darker color wheel pigments, such as permanent green. This will lighten the green somewhat but will also shift the green toward yellow-green. To achieve a wide range of values, white is clearly indispensable, but, as is often true with artists' pigments, there is a price to pay.

It may surprise you to know that white in mixtures tends to deaden colors, especially when the mixture already contains two or more pigments. Recall that in chapter 3, I suggested that our brick-wall painter might need to add a speck of *yellow* to her pale, dull orangish red mixture to restore the hue's colorfulness. Her mixture already contained four pigments: cadmium orange and cadmium red to make red-orange, plus ultramarine blue and permanent green to make blue-green for lowering the intensity of the red-orange. When she added the white, which was necessary to lighten the mixture, it also deadened the color.

To bring life back to the color, the artist chose to add a tiny speck of yellow. Why yellow rather than orange,

Fig. 6-9. This painting by the eighteenth-century French artist Jean-Baptiste Oudry is a study in values of white. If you look closely, you will see that parts of the white duck (the shadowed area under the wing, for example) are almost black, as is the shadowed side of the white candle.

Oudry, *The White Duck*, 1753.

more red-orange, or even some other hue? Because yellow is already part of the red-orange mixture (recall that orange is made from red and yellow) and already part of the blue-green mixture (green is made from blue and yellow). Yellow, therefore, will lighten and brighten both colors, whereas additional orange or red-orange would simply overwhelm the dulling effect of the blue-green and she would be back where she started. Had she chosen to add an extraneous color such as red-violet or blue-violet, the mixture would have quickly turned into mud, and she would have had to start over.

Another Way to Darken a Color

The easiest way to darken a color is to add black, but black pigment added to mixtures also tends to deaden colors. Another way to darken a color is to add one of the darker color wheel pigments, such as blue or violet, to mixtures of the lighter hues, such as yellow-green or yellow-orange. This will dull the lighter color and change its hue, but it will still be vibrant and colorful. On the other hand, black added to yellow results in some beautiful olive greens, and black added to orange and red-orange results in some very useful browns.

Summing Up

For reasons that are unclear, identifying the value of individual colors is difficult. Judgments of value are judgments about relationships, which are more difficult to make than judgments about categories. By providing yourself with an actual gray scale to use for comparative judgment, you will find that it becomes much easier to identify the value level of a given hue. Moreover, in time and with practice, you will replace the actual gray scale with a memorized mental gray scale.

"The human eye is, in fact, an excellent detector of differences of hue, and many people can assess the percentage of red, blue, and yellow in a pigment with surprising precision. But human estimates of saturation (intensity), and of brightness (value), are much less reliable."

Hazel Rossotti, *Colour: Why the World Isn't Grey*, 1983

This skill does require practice, however. I recommend that, for practice, you take a few minutes each day to work with your value wheel. Pick a color out of your environment and make a guess at its value level on your clock/value scale, with white at 12 o'clock and black at 6 o'clock. Once you have estimated the value level of a color, check it by holding up your value wheel, looking at the color through one of the holes in the outer wheel, and turning the wheel until you find a match. In a very short time, you will find yourself assessing the values of colors with surprising accuracy. Many beginning painting students have trouble with this aspect of color, but I believe that this is not a failing of perception but rather a matter of not having acquired a memorized gray scale against which to judge values.

In the next chapter, we'll take up the third attribute of color, intensity (the color's brightness or dullness). As with the perception of value, the perception of intensity requires that you have a mental image of an intensity scale against which to judge the brightness or dullness of a color you are seeing.

CHAPTER 7

Using the Color Wheel to Understand Intensity

THE THIRD ATTRIBUTE of color, intensity, is the brightness or dullness of a hue. Note that the word *dull*, meaning low intensity, can be misleading. Low-intensity colors are not dull, in the everyday sense of the word. In color terminology, the term has a specific meaning: dulled hues are colors made *less bright* (lowered in intensity) by adding other colors, usually complements, or by adding black.

The word *bright* also has a special meaning in the vocabulary of color. As you learned in constructing your color wheel, the brightest colors you can achieve with pigments are the pure colors as they come out of the tube or bottle. It is not possible to make pure colors brighter by adding other pigments. You can lighten pure colors or darken them (change their values) and you can dull them (lower their intensities), but you cannot make them brighter. Interestingly, you can make pure colors *seem*

brighter by juxtaposing them with other colors, especially with their complements or with black or white, thus causing simultaneous contrast to affect the colors' *apparent* brightness. But you cannot make the pigments themselves brighter than they are in their inherent intensity. You also can brighten a dull color by adding pure pigment, but this mixture will never be as bright as the pure color from the tube or bottle.

What follows is a quick but very important little exercise—an interesting experiment—that will clarify why pigment mixtures, especially mixtures of complements, have the ability to dull each other. This aspect of color is important to understand because knowing how to lower intensity is one of the most powerful tools for harmonizing color.

Color theory tells us that mixing three primaries subtracts all color wavelengths, resulting in black. If we had pure spectrum primary pigments of yellow, red, and blue, we could easily achieve a true black by a mixture of the three. When combined in equal quantities, the printing ink primaries cyan, yellow, and magenta yield a beautiful black (Figure 7-1). With traditional pigments, however, we can only dull paint to the point of canceling color, never quite reaching black. You will, however, achieve a no-color hue that my students named "yuk," a term that is quite descriptive but belies the beauty of most low-intensity or dulled colors.

Exercise 7. The Power of the Primaries to Cancel Color

1. Set up your palette with your primary pigments— cadmium yellow pale, cadmium red, and ultramarine blue.
2. In the center of your palette, mix the three primaries in approximately equal quantities.
3. If the mixture seems a little green (blue plus yellow), add more red, the complement to green. If the

Beginners in color often think that if a hue is pale it must be bright, and if a hue is dark it must be dull.

This is not necessarily so. A very dark blue can also be bright (think of the fabric color "bright navy"). A very pale yellow can be very dull (think of dried grasses in a field).

Fig. 7-1. When combined in equal quantities, the printing ink primaries yellow, cyan, and magenta yield a beautiful black.

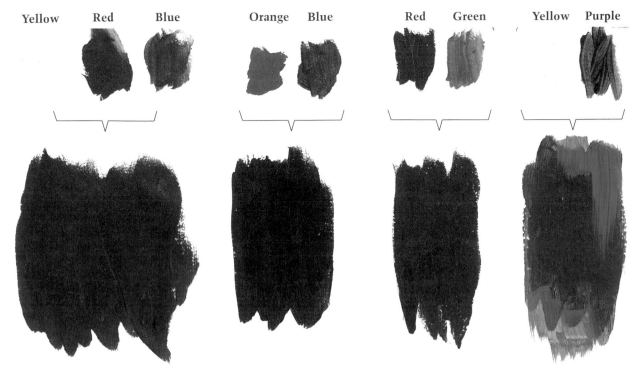

Yellow Red Blue Orange Blue Red Green Yellow Purple

Fig. 7-2. The three primary colors and all complementary colors *cancel color* **when mixed together in about equal quantities.**

Recall that any two complements contain all three primaries.

mixture seems a little orange (yellow plus red), add its complement, blue.

4. Continue to adjust the mixture by adding small amounts of the complement of any hue you can still perceive in the mixture, until *no color* is discernible.

5. Paint a swatch of your no color on a scrap of paper (Figure 7-2).

6. Next, add your secondary pigments—orange, green, and violet—to the three primaries already on your palette.

7. Mix blue and orange together, adjusting the mixture until you have again canceled color and achieved a no-color mixture. Paint a swatch next to your first no-color swatch on the same scrap of paper.

8. Mix red and green until you have a no-color mixture. Paint a swatch on the same paper.

9. Mix yellow and violet until you have a no-color mixture. Again, paint a swatch.

10. Now compare your four swatches: one from a mixture of three primary hues, and three from mixtures of complements (Figure 7-2). The mixtures of complements will not be exactly the same no-color hue as your mixture of primaries, because of differences in the chemical structure of pigments, but all of the no-color hues will be closely related to your no-color mixture of the primaries.

11. Return to your color wheel now and paint the circle in the center using your best no-color mixture—the one that reflects the least color. When you use your color wheel for the later exercises, having a spot of no color in the center will remind you that:

- A mixture of equal quantities of the three primaries will completely cancel color.
- Every pair of complements (any two colors opposite each other on the wheel) contains all three primary hues—red, yellow, and blue— therefore, any pair of complements, mixed together, can dull each other to no color.
- You can incrementally lower the intensity (that is, reduce the brightness) of any color by incrementally adding its complement.

With this exercise, you have observed the power that the three primary hues can exert on each other. Having seen with your own eyes this canceling power, you will not make the mistake many students make—dipping into pigment after pigment after pigment trying to mix a specific color. Complementary colors yield beautiful low-intensity hues, but adding a third and a fourth pigment will quickly cancel all colors completely, and the result is...buckets of mud.

You will rarely use the fundamental ability of primary pigments to completely cancel each other to no color, but you will constantly use complements because the two together supply the three primaries needed to lower a hue's

"Two such [complementary] colors make a strange pair. They are opposite, they require each other. They incite each other to maximum vividness, when adjacent; and they annihilate each other, to gray-black, when mixed — like fire and water."

Itten, *The Art of Color*

There is a saying among art educators that a person just starting out in color will mix ten gallons of mud before learning how to make beautiful color. This is expensive and frustrating.

With these exercises, I am hoping to spare you that experience.

intensity without destroying its inherent colorfulness. As you will learn in a later exercise, rich, low-intensity colors provide the deep, resonant notes that make light-bright, medium-bright, or dark-bright hues sing.

Nature is the best model for this aspect of color. The predominant colors of nature are low-intensity (dull) browns, greens, and blues. They form a rich, deep background for the high-intensity notes of flowers, leaves, birds' plumage, and fishes' scales (Figure 7-3).

Exercise 8. Creating an Intensity Wheel—
From a Pure Hue to No Color and Back Again

An intensity wheel, like your color wheel and value wheel, is arranged in twelve equal steps around a clock-face pattern. You will be using complements to go from a pure color wheel hue at 12 o'clock to no color at 6 o'clock by adding the hue's complement in small, equal increments until the color is canceled. You will then incrementally add the pure hue you started with to your no-color mixture in increments until you arrive back at 12 o'clock with the original hue. This exercise provides excellent practice in dulling (lowering the intensity) of a hue and then brightening it (bringing it back to full intensity) by adding the pure pigment. The process is the same for all hues, and by making an intensity wheel you will be able to extrapolate intensity levels for other hues.

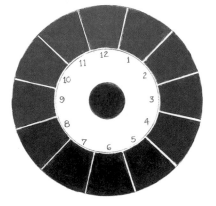

Fig. 7-4a. Intensity wheel for the complements orange and blue. The clock face makes it easy to determine *opposite* intensities.

1. Use your template again to make an intensity wheel. For this wheel, draw the small circle in the center of the wheel, but omit the hue-finder square.
2. Choose two complementary colors: orange and blue, red and green, yellow and violet, red-orange and blue-green, or any of the other color pairs that lie opposite each other on the color wheel.
3. Let's say you have chosen the complements orange and blue. Figure 7-4a shows an intensity wheel for cadmium orange and its complement, ultramarine blue. At 12 o'clock, paint *orange*, using your cadmium orange right out of the tube or bottle. Be sure that your brush is clean and the water you rinse it in is clean. That is the brightest orange you can achieve.
4. In the circle in the center of the wheel, paint *ultramarine blue*, the complement of orange.
5. Begin to add a bit of ultramarine blue to the orange pigment on your palette and paint this first step

in dulling (lowering the intensity of) orange at 1 o'clock.

6. Mix again, adding slightly more blue, and paint at 2 o'clock.

7. Mix again, add more blue, and paint at 3 o'clock. At this point, you are halfway to no color. Your mixture should still look orange, but definitely a dull orange (Figure 7-4a).

8. Continue adding additional blue through 4 and 5 o'clock.

9. At 6 o'clock, you will arrive at *no color*, a color that looks neither orange nor blue, since color is completely canceled. (Recall that orange, made from yellow and red, together with blue *complete* the primary triad.)

10. Next, check for even steps in your intensity wheel, 1 through 6 o'clock. If there are some scale jumps (uneven steps), you can correct your mixtures and repaint any steps that need correcting before completing the wheel.

11. Complete your intensity wheel by painting even steps from no color at 6 o'clock back again to slightly dull orange at 11 o'clock by incrementally adding orange pigment. (See Figure 7-4b for an orange/blue intensity wheel showing even steps.)

12. Pencil in the clock-face numbers.

Fig. 7-4b. A second intensity wheel, this one starting with blue at 12 o'clock and dulling blue with orange to no color at 6 o'clock. Because spectrum blue is darker in value than spectrum orange, the steps to reach no color are smaller than the steps from orange to no color.

Using the clock-face mnemonic makes it easy to determine the opposite intensity level for each hue, and to see that relationship (Figure 7-4b). Intensity level 1 is opposite intensity level 7. The opposite of no color at 6 o'clock is pure, bright blue at 12 o'clock. We will use these opposite values and intensities in our color harmony exercise in chapter 8.

Exercise 9. Practice in Naming Hue, Value, and Intensity

Now that you have mixed and painted the three attributes of color, it is time to practice naming colors. Look around the room in which you are sitting. Every color you see, including the colors of wooden furniture, can be named. Try it out. Each color is what it is, and your job is to translate the hue into its three attributes. Once you have determined the source color, decide for each hue how light or dark it is and how bright or dull. For value levels and intensity levels, you may wish to use word designations, you may prefer number designations, or, for greater precision, you may want to use both, as in these examples: Red, light (level 2), and very dull (level 5); or, Blue-green, medium value (level 3), and bright (level 2). Can you visualize these two colors?

Fig. 7-5. Name the source hue, the value level, and the intensity level for each of these colors. (Key is on page 81.)

1. Here is a set of six colors. For each, name the hue, the value level, and the intensity level. For each of the attributes, refer to your color wheel, your value wheel, and your intensity wheel.

2. Next, set your wheels aside and choose a color from your surroundings to name by its three attributes.
3. Choose an object made of wood and name the three attributes of its color.
4. Choose an object made of metal and name the three attributes of its color.
5. Choose an object made of plain-colored fabric and name the three attributes of its color.
6. Remind yourself to name colors that catch your attention during the day.

If possible, it is very good practice to do another intensity wheel—or several, if time permits. The template makes it quick and easy to construct another wheel. Choose a different set of complements—perhaps two tertiary colors such as yellow-orange and blue-violet. Can you see in your mind's eye how those two hues will change when mixed together? If not, I urge you to try it.

Other Ways to Dull Colors

You may be asking yourself, "Why not just add black to dull a color?" Black is an important pigment in painting and, in my view, should not be eliminated from the palette, as some artists still occasionally recommend because certain of the Impressionist painters banished black. As you learned in chapter 5, black is useful for making hues *darker*—that is, lower in value—while still retaining some of the brightness of the original hue. Black added to ultramarine blue will make a very dark (value level 5) but still medium-bright blue, or, added to alizarin crimson, a very dark (value level 5) but medium-bright red. As I have previously noted, in certain combinations, black added to pure pigments results in unexpected and useful hues. By adding black to cadmium orange, for example, you can mix some beautiful browns. Black in combination with cadmium yellow pale yields some surprisingly beautiful bright olive greens. You might try some of these mixtures.

When black is used indiscriminately to *dull* hues (meaning to lower intensity), it does indeed dull colors, but it can be *too* effective, especially if the hue is already a mixture of two or more colors before adding black. Often, the result is really dull, really flat colors. When you use the *complements of hues* to dull colors, you achieve rich, vibrant hues, which reflect the life of the contributing spectrum hues.

As you leave this chapter, you can feel confident that you now have all of the basic information and practice you need to begin creating harmonious color arrangements. In earlier chapters, you learned the importance of the color wheel and how to use its twelve colors to identify hues, and you learned to use a gray scale clock wheel to determine the value level of colors. In this chapter, you learned how to use your hue scanner to escape the effects of color constancy and simultaneous contrast in order to correctly identify hues, and how to manipulate the brightness and dullness of colors by using complements. In the next chapter, you will put all of this knowledge to practical use by creating a painting with a harmonious arrangement of colors.

Key to Figure 7-5.

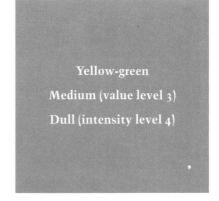

Yellow-green
Medium (value level 3)
Dull (intensity level 4)

Yellow-orange
Light (value level 2)
Medium (intensity level 3)

Blue-green
Dark (value level 4)
Medium (intensity level 3)

Blue
Light (value level 2)
Bright (intensity level 2)

Red
Dark (value level 4)
Medium (intensity level 3)

Red-orange
Light (value level 2)
Bright (intensity level 2)

Using the Color Wheel to Understand Intensity

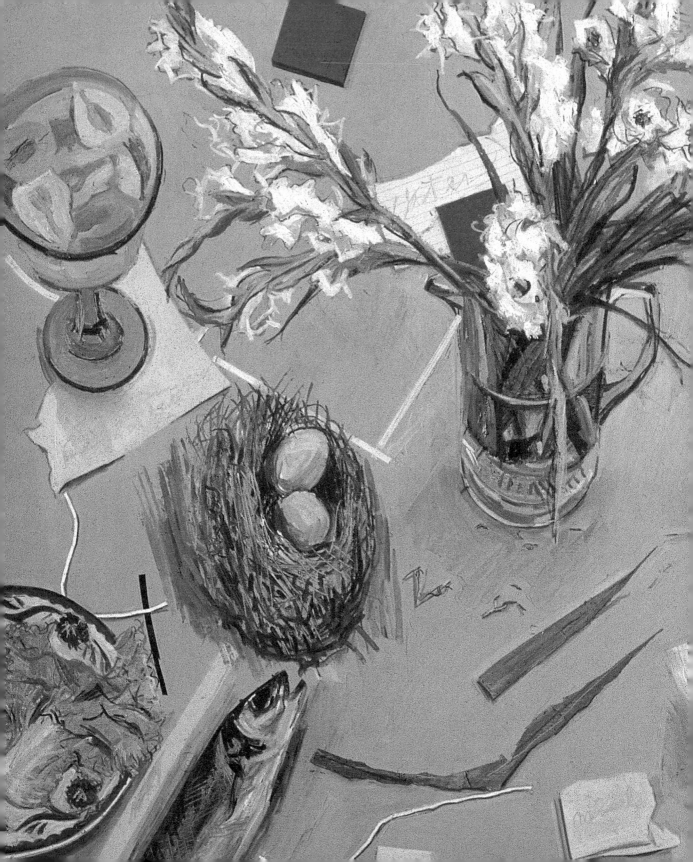

PART III

CHAPTER 8

What Constitutes Harmony in Color?

About his ten-year study of color, *Farbenlehre*, German writer and scientist Johann Goethe (1749–1832) said:

"As for what I have done as a poet, I take no pride in it whatever... But that in my century I am the only person who knows the truth in the difficult science of colors, of that I say I am not a little proud."

ONE OF THE as yet unanswered questions is, "What constitutes harmony in color?" Harmony in color is generally defined as a pleasing arrangement of colors, but the definition tells us nothing about how to achieve color harmony. In music, conversely, the study of harmonics deals with the scientific properties of musical sounds and enables scientists to specify musical harmonies and how to achieve them.

A story is told that the poet and scientist Johann Goethe, who was not a painter, wondered what constituted harmony in color. Goethe's musician friends had assured him that harmony in music was well understood and codified, but what about color? Goethe went to his artist friends to find out, and, to his surprise and dismay, none of them could give him a satisfying answer. It was partly this conundrum that inspired his immense study of color, *Farbenlehre*. If his friends chided him that searching for

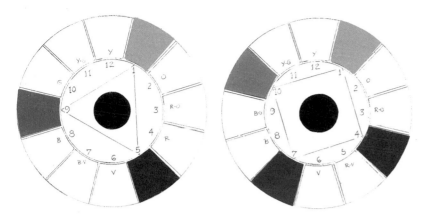

Fig. 8-1. Fig. 8-2.

Fig. 8-1. The triad yellow-orange, red-violet, and blue-green. Find the third triadic color for red-orange and blue-violet. Note that all triads mixed in equal quantities cancel color to no color.

Fig. 8-2. The tetrad yellow-orange, red, red-violet, and green. Find the two tedradic colors for violet and yellow. Again tetradic colors mixed in equal quantities cancel color to no color.

rules of harmony was too restrictive and uncreative, Goethe defended himself by saying that it was important to know the rules, if only for the privilege of breaking them.

Nearly every writer on color proposes one theory or another on how to achieve harmonious color. Some recommend analogous color schemes, some suggest complementary colors, others triadic schemes (three hues equidistant on the color wheel; see Figure 8-1), or tetradic arrangements (hues at four points on the wheel; see Figure 8-2), and still others—German colorist Johannes Itten, for example—recommend all of the above.

In his book *The Interaction of Color*, American artist, teacher, and color expert Josef Albers emphasized the importance of *quantitative* color relationships (the size and placement of one hue's area relative to that of another) in order to produce either harmony or dissonance (which Albers believed to be as valuable as harmony).

The Aesthetic Response to Harmonious Color

The strange thing about color harmony is that, whether one is trained or untrained in color, we are aware that some color combinations please us greatly, even though we may not know why they please us or how to produce such com-

"We can make the general statement that all complementary pairs, all triads, whose colors form equilateral or isosceles triangles in the twelve-member color circle, and all tetrads forming squares or rectangles, are harmonious."

Itten, *The Art of Color*

"We emphasize that color harmonies, usually the special interest or aim of color systems, are not the only desirable relationship. As with tones in music, so with color — dissonance is as desirable as its opposite, consonance...And all of this can be achieved mainly through changes in quantity which result in shifts of dominance, of recurrence, and consequently of placement."

Albers, *The Interaction of Color*, 1963

binations. When we encounter a beautiful color arrangement that gives us particular pleasure, we experience a phenomenon called the aesthetic response, sometimes called "the aesthetic experience." The aesthetic response is a "notoriously slippery concept," to quote the well-known art historian and critic E. H. Gombrich. Perhaps it can best be described in poetic terms, as in Wordsworth's lines:

> *My heart leaps up when I behold*
> *A rainbow in the sky...*

Sigmund Freud said, "The enjoyment of beauty produces a particular, mildly intoxicating kind of sensation." The Greek philosopher Socrates said, "Beauty is certainly a soft, smooth, slippery thing, and therefore of a nature which easily slips in and permeates our souls."

Art historian Michael Stephan, in his 1990 book *The Transformational Theory of Aesthetics*, proposed that the aesthetic experience originates in the brain's right hemisphere as a response to satisfyingly coherent and harmonious relationships of parts to the whole. Stephan believes that this wordless, heart-leaping response of delight is sensed by the left hemisphere, causing the brain's verbal centers to try to put into words the nonverbal *feeling* engendered by the right hemisphere's perception.

In this book, I am following Goethe's thought that the response of delight elicited by certain color harmonies may be linked to a phenomenon called "after-images," which suggests that the human brain longs for balanced relationships across the three attributes of color.

The Phenomenon of After-images

An after-image is a ghostly but brilliant apparition of a complementary color that appears after gazing steadily at a hue, then shifting the eyes away to an uncolored surface. This visual sensation is one of the most startling aspects of color, and one that has intrigued scientists for centuries.

Color by Betty Edwards

·

Figure 8-3 demonstrates the after-image phenomenon. Gaze steadily at the black dot in the center of the blue-green diamond for about twenty seconds (count slowly to 20). Then cover the diamond with your hand and quickly shift your gaze to the dot at the right of the diamond. A glowing red-orange diamond—the complement to blue-green and its opposite on the color wheel—will magically appear on the blank page, persist for a few moments, then gradually fade away.

In another example (Figure 8-4), gaze at the dot in the yellow rectangle, and then shift your gaze to the dot at the right. Again, the color wheel complement of yellow—violet—will appear as a ghostly apparition in the same rectangular shape as the original yellow. The sensation also occurs with black-and-white images. Try it out in Figure 8-5.

Fig. 8-3. Gaze at the black dot in the center of the diamond while you count slowly to 20. Then shift your gaze to the dot at the right.

"When the eye beholds a color, it is at once roused into activity, and its nature is, no less inevitably than unconsciously, to produce another color forthwith, which in conjunction with the given one encompasses the totality of the color circle ... In order to realize this totality, in order to satisfy itself, the eye seeks, beside any color space, a colorless space wherein to produce the missing color. Here we have the fundamental rule of all color harmony."

Goethe, *Farbenlehre*

Fig. 8-4. Repeat the after-image process, counting slowly to 20 and shifting your gaze to the dot at the right.

Fig. 8-5. Again gaze at the center dot, count slowly to 20, and shift your gaze to the dot in the white area. Continue to focus on the dot until the reverse image appears (usually in two or three seconds).

Color by Betty Edwards

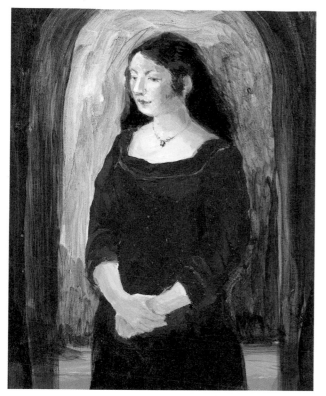

You may well ask "What is going on here?," just as others have been asking for hundreds of years. In 1883, Johann Goethe reported the following incident: "I had entered an inn towards evening, and, as a well-favoured girl, with a brilliantly fair complexion, black hair, and a scarlet bodice, came into the room, I looked attentively at her as she stood before me at some distance in half shadow. As she presently afterwards turned away, I saw on the white wall, which was now before me, a black face surrounded with a bright light, while the dress of the perfectly distinct figure appeared of a beautiful sea-green."

I have conjured up Goethe's "well-favoured girl" in Figure 8-6. Repeat his experience by gazing at her necklace while slowly counting to 20, and then, turning to the white rectangle at the right, focus on the black dot. Your eye/brain/ mind system will replicate for you Goethe's experience.

Fig. 8-6. Goethe's "well-favoured girl." Focus on the pendant of her necklace while slowly counting to 20. Then cover the image with your hand and focus on the black dot in the white format to the right. Maintain your focus on the dot until the after-image appears.

Seeing the after-image phenomenon for the first time often elicits "Oh's" and "Ah's" of amazement.

While I was teaching at the university, I often thought how amusing it would be for someone to drop into my classroom just as the students were "Ooh'ing" and "Ahh'ing" at a blank white wall.

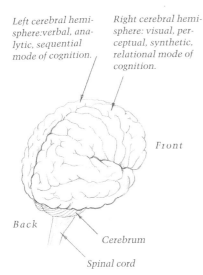

Fig. 8-7.

Goethe analyzed this event as follows: "As the opposite color is produced by a constant law in experiments with coloured objects on portions of the retina, so the same effect takes place when the whole retina is impressed with a single colour . . . Every decided color does a certain violence to the eye, and forces the organ to its opposition."

Scientists have proposed many theories to explain after-images, among them the theory that gazing at a color causes color receptors in the eyes to become fatigued and that these receptors then restore visual balance by producing the complementary after-image. Today, after-images are regarded as short-lived visual sensations, the cause of which is still not fully understood. Having said that, however, it seems inescapable that this strange mechanism of the human visual system may be linked to our aesthetic sense of harmonious and satisfying color arrangements.

After-images and the Attributes of Color

An after-image is *always* the complement of a gazed-at hue, not only of the bright color wheel hues but also of *any* hue. If you gaze at a full-intensity green, the after-image will be full-intensity red. If you gaze at a pale, dull green, the after-image will be a pale, dull pink. The human brain and our visual system apparently want to complete the primary triad by producing a color's exact complement, including the value and intensity levels. I believe that more than any other aspect of color, after-images reinforce the important roles that complementary hues, value, and intensity play in harmonizing color

Figure 8-8, *Red Blue Green*, 1963, is a masterwork by American artist Ellsworth Kelly. It is nearly 7 feet high and over 11 feet long. The *Los Angeles Times* art critic Christopher Knight wrote the following insightful analysis of the painting:

> "...Red, blue and green are not the three primary colors when it comes to mixing pigments (yellow would take the place of

green); instead they're the primaries for mixing projected light. Can it be an accident that Kelly's 1963 painting dates to the period when color TV began to explode across the American landscape? Kelly's art isn't Pop, but neither does it ignore the cultural zeitgeist.

The color-shapes are also carefully calibrated. The red and the slightly wider blue shapes seem suspended from the upper left and right corners, with the blue dipping into a curve that's a little bit lower than the straight bottom edge of the red rectangle. Between them, the eccentric "leftover" shape is painted green.

Because of this eccentricity, the eye automatically reads the red and the blue as foreground shapes against a green background. But then the painting snaps into place as a flat, two-dimensional field, where no illusion of depth or of objects in space can be maintained. There are a couple of reasons for this.

One is the relative quantities of color—more serene blue than fiery red, which together balance out against a green field that suddenly seems almost neutral. Another is the visually stable shape of a rectangle in the eye-dazzling color, while the swinging, swooping shape on the other side is in the calmer hue. And

Fig. 8-8. Ellsworth Kelly (b. 1923), *Red Blue Green*, 1963, oil on canvas, 212.1 × 345.1 cm (83⅝ × 135⅞ in.). Museum of Contemporary Art San Diego.

the juxtaposition of red and green creates an optical line of vibration at the left, while the longer border of blue and green at the right is steadfast as can be.

Finally, the eccentric green shape spreads out beneath the red rectangle and the blue curve to reach the edges of the canvas at either side. It seems to lock everything into place. This is an immensely complex, sophisticated orchestration of size, shape, color, line and composition, which at first glance appears to be as simple as pie . . ."

"A Pivotal Call to Colors," by Christopher Knight. *Los Angeles Times Calendar*, March 23, 2003. Reprinted with permission of the *Times* and Mr. Knight.

Another of the many great things about this painting is that it triggers multiple after-images. Because the work is so large, one can focus on one of the three colors at a time. If you gaze at the blue for about 20 seconds, then turn to the red rectangle, the center of the rectangle becomes a glowing orange. If you focus on the red and then turn to the blue, the blue transforms to blue-green. Meanwhile, the central green seems to shift in value at its edges, making the whole painting appear fluid in color.

Years ago, when I was teaching art classes for young children, I had a striking experience that seems to illustrate the brain's longing for the complements of colors. One child, about six years old, had covered a large piece of paper with bright green paint applied in various textures and thickness. He paused and stood looking at his painting. I asked him, "Is it finished?" He gazed at it thoughtfully for another moment and then picked up a brush loaded with red paint. He let a few red drops fall on his green painting, put down the brush, and said, "There, it's finished."

Albert Munsell's Theory of Harmony Based on Balancing Color

In his definitive 1921 book, *A Grammar of Color*, renowned American colorist Albert Munsell proposed a theory of harmony based on the concept of balancing color. A dilemma

with Munsell's theory is the impenetrability of his writing. His book is dense and difficult, and his ideas often had to be translated by friends and associates.

I had never fully grasped his thesis, I believe, until my color theory students worked on the color transformation exercise I described in chapter 3 —the exercise that I invented out of necessity to teach art students how to see and mix colors. The exercise was actually very simple. Students started with a given set of colors (it didn't seem to matter what the original colors were, whether beautiful or insipid or vulgar or downright ugly). Introducing no additional extraneous hues, they transformed the given colors to their complements and then to the opposite values and intensities, and ended with balanced, aesthetically satisfying, even beautiful color harmonies. Only after they had completed their paintings did I realize that they had balanced color across the three attributes as Munsell, in his abstruse way, had recommended, and that, like magic, by balancing color in a closed, coherent combination, they had produced harmonious color.

I propose that this method of balancing color results in a "locked-in," coherent color arrangement (a "closed system," in psychobiologist and Nobel Laureate Roger Sperry's terms; see sidebar on page 86) in which every hue is varied across its attributes and no color is out of synchrony with the others, like a musical fugue with a theme that is stated and then restated in variations. In addition, I propose that aesthetic pleasure (the aesthetic response) is elicited by color sets balanced across their three attributes.

A Definition of Balanced Color

Balancing a set of hues means providing what the human brain seems to long for in color:

- Complements at the same value and intensity levels for each hue in a design.

One of Munsell's collaborators wrote:

"Munsell was not much of a writer, and though he could think and speak coherently, to all indications he found the task of author a difficult one."

T. M. Cleland, *Munsell: A Grammar of Color*, 1969

1

2

3

4

5

GUEST PASS

MCA X SD

6

7

Fig. 8-9. Courtesy of 2x4 and the
Museum of Contemporary Art
San Diego.

- Opposite values for each hue.
- Opposite intensities for each hue.

For an illustration of how this works in a real-life solution to a color problem, I offer the example of the color scheme designed for the Museum of Contemporary Art San Diego. Color in corporate image building has spawned a design specialization, and today nearly every organization seeks to be identified by color in logos, stationery, advertisements, and vehicles. The museum director commissioned a New York design firm, 2x4, to establish a new graphic identity for the museum. Figure 8-9 shows the beautiful result. The design is based on a light (value level 2), bright (intensity level 2) blue and its complement, light, bright orange. The color transformation is diagrammed below.

The 2x4 designers started with light bright blue (1) and its complement, light bright orange (2). They then added:

(3) Very light dull blue
(4) Dark bright orange
(5) Very dark dull orange (dark brown)
(6) Very dark dull blue

The transformation resulted in six hues (Figure 8-9).

To this harmonized color combination, the 2x4 designers added one quirky touch: a very pale (value level 1) bright (intensity level 2) green (number 7 in Figure 8-9). The color is not strong enough to disturb the harmonious whole, and adds just a bit of whimsy well suited to the contemporary focus of the museum.

With your new knowledge of color, you can duplicate this kind of color expertise in your own surroundings. If you were to start with *two* colors, say, blue and green, the process would be repeated for both colors, resulting in about sixteen hues. Obviously, to harmonize this number of colors is more difficult, and you would have to pay close attention to the relative *quantities* of each hue.

In the next chapter, you will complete a project that involves transforming, balancing, and harmonizing colors. In doing so, you will put into practice all of the knowledge you have gained so far:

Photo: Carlos Guillen.

- How to use the color wheel to identify hues based on the twelve color wheel source hues (the primary, secondary, and tertiary colors).
- How to isolate individual hues in order to escape the effects of color constancy and simultaneous contrast.
- How to mix colors that match perceived hues.
- How to identify and mix complementary colors.
- How to use the attributes of color to mix hues of specific values and intensities.
- How to use the attributes of color to mix the opposite values and intensities.

9

Creating Harmony in Color

A N INTERESTING ASPECT of color harmony (as I am using the term) is that you can start with almost any single color, or any set of two, three, four, or even five randomly selected colors, and create a beautifully harmonized color composition by transforming each of those hues into their complements (at the same value and intensity levels) and into their same or opposite values and intensities. You will see this for yourself in the following exercise on transforming color.

Exercise 10. Transforming Color Using Complements and the Three Attributes: Hue, Value, and Intensity

Unlike previous exercises, this one is more detailed and challenging—you may want to divide it into segments of approximately thirty minutes each. But this exercise *sums up* basic color knowledge and will provide you with a deep

"The colors diametrically opposed [on Goethe's color circle] are those which reciprocally evoke each other in the eye. Thus yellow demands purple, orange, blue, and red, green, and vice versa."

Goethe, *Farbenlehre*

Fig. 9-1a. Detail showing fabric and matching hues by student Lorraine Cleary.

Fig. 9-1b. Detail diagram of Cleary's color exercise. Key: 1. Fabric; 2. Matching colors.

Fig. 9-1c. The completed design. Key: 1. Fabric; 2. Match of the original colors of the fabric; 3. Direct complements of the original colors; 4. Opposite values of the original colors; 5. Opposite intensities of the original colors; 6. Return to a match of the original colors of the fabric.

Fig. 9-2a. Detail showing fabric and matching hues by student Lisa Hastings.

Fig. 9-3a. Detail showing fabric and matching hues by student Vivian Souroian.

Fig. 9-2b. Detail diagram showing Hastings's color exercise. Key: 1. Fabric; 2. Match of the hues of the fabric.

Fig. 9-3b. Detail diagram of Souroian's exercise. Key: 1. Fabric; 2. Match of the fabric colors; 3. Complements of the original hues; 4. Opposite values of original hues.

Fig. 9-2c. Key: 1. Fabric; 2. Match of the hues of the fabric; 3. Complements of the original hues at the same value and intensity levels; 4. Opposite values of the original hues; 5. Opposite intensities of the original hues.

Fig. 9-3c. Key: 1. Fabric; 2. Match of the fabric colors; 3. Complements of the original hues; 4. Opposite values of the original hues; 5. Opposite intensities of the original hues; 6. Return to a match of the original hues.

Fig. 9-4a. Detail showing fabric and matching hues by student Carla Alford.

Fig. 9-5a. Detail showing fabric and matching hues by student Troy Roeschl.

Fig. 9-4b. Detail diagram showing Alford's color exercise. Key: 1. Fabric; 2. Match of the fabric colors.

Fig. 9-5b. Detail diagram showing Roeschl's color exercise. Key: 1. Fabric; 2. Match of the fabric colors.

Fig. 9-2c. Key: 1. Fabric; 2. Match of the fabric colors; 3. Complements of fabric colors; 4. Opposite values of the original hues; 5. Opposite intensities of the original hues; 6. Return to the original fabric colors.

Fig. 9-5c. Key: 1. Fabric; 2. Match of the fabric colors; 3. Complements of original hues; 4. Opposite values of the original hues; 5. Opposite intensities of the original hues; 6. Return to the original fabric colors.

Fig. 9-6. Tape the edges of your 10" × 10" illustration board, using low-tack artist's masking tape.

Fig. 9-7. The 10" × 10" fabric.

Fig. 9-8. Black-and-white photocopy of fabric.

understanding of the structure of color. In addition, the painting you will be creating in the exercise will be beautiful and will engender a reaction of pleasure, which you will experience yourself on its completion, and which others will experience on viewing your work. Figures 9-1 through 9-5 show you student examples of the completed exercise.

Part I. Setting Up For Exercise 10

1. You will need a 10" × 10" piece of illustration board. With your ¾-inch low-tack masking tape, tape off the edges, placing one edge of the tape right at the edge of the illustration board to make the protected white margins even. When you remove the tape after you complete the painting, you will have a white border for your painting that is the width of the tape (Figure 9-6).

2. To start your design, find some patterned fabric, some gift-wrapping paper, or even wallpaper with a design and colors that you like. Cut out a 10" × 10" square piece of the chosen design (Figure 9-7). It doesn't seem to matter what the design is or what the color scheme is in terms of the beautiful outcomes of this project, but you will be working on it for a number of hours, so clearly it's best if you like the colors and the design. The examples of students' finished paintings in Figures 9-1 through 9-5 may help you in choosing a pattern.

3. If you have chosen a fabric design, I urge you to make a photocopy of your 10" × 10" piece of the fabric in black and white because it is much easier to transfer the design using graphite paper under the paper copy rather than under actual fabric. If you are using a gift-wrapping paper design or wallpaper, you don't need a photocopy for tracing the design, but having a black-and-white copy is sometimes helpful when you come to the value transformations of the design (Figure 9-8).

4. Next, tape the photocopied design of the original piece of fabric, wrapping paper, or wallpaper onto your illustration board, placing the graphite paper between the photocopy and the board. Trace the design onto the illustration board.

5. Next, using pencil, divide your 10" × 10" design into six areas, using any type of division you like (Figure 9-9). The divisions may be geometric—a set of squares or circles—or they may be drawn free-hand into swirling shapes, diagonal stripes, or shapes radiating from a central shape. This aspect of the project is completely your choice. Figures 9-1 through 9-5 show some divisions students have used in the past. You may wish to number each area lightly in pencil and label each section, using the *italicized* and <u>underlined</u> designations below.

6. Then, returning to the actual 10" × 10" cloth or wrapping-paper design, choose a small area that includes all of the colors in the pattern. It can be located anywhere within the 10" × 10" square of fabric or paper design. It should be about 1¾" to 2¾" in width and length. Cut this area out. Depending on your design, the shape may be a circle, a square, a triangle, an oval, or a random shape (Figure 9-10).

7. Match up the cutout piece of the original fabric or paper design with the area on the traced design on your illustration board. Glue it into place, using ordinary white glue or, if you have it, special fabric glue available in craft stores. This will become "Area 1" of six areas in your design. Area 1 provides the original starting colors for your painting (Figure 9-11).

Fig. 9-9.

Fig. 9-10. Fabric with piece cut out.

Fig. 9-11. Design drawn in pencil with cutout fabric in place.

Part II. Performing Exercise 10

The following list provides an overview what you will be doing with each of the six areas. For each area from 2 through 6, you will call on a segment of the color knowledge you have gained so far.

- **Area 1.** This area will be completed once you have pasted the small piece of *actual fabric* (or wrapping paper or wallpaper) in place on the illustration board.
- **Area 2.** You will see, name, mix, and paint the *exact match* in hue, value, and intensity of the colors in the actual fabric or paper design.
- **Area 3.** You will see, name, mix, and paint the *exact complements* of the original hues, meaning complements at the same value level and intensity level as each original hue.
- **Area 4.** You will see, name, mix, and paint the *opposite values* of the original hues.
- **Area 5.** You will see, name, mix, and paint the *opposite intensities* of the original hues.
- **Area 6.** *You will repeat the match of the original hues* of the actual fabric or paper design.

Instructions for Areas 2 Through 6

Area 2. Matching Colors

Matching the original hues in area 1 requires *seeing* each color in the original pattern, *naming* it, and then *mixing* it. While matching colors may seem elementary, it is an important skill in painting. Imagine, for example, attempting to paint a portrait and being unsure of how to match the colors of skin, hair, and clothing. For area 2 of the exercise, you will be matching each color in your pasted-on original sample in area 1.

1. You will be painting the same matching colors in area 6 after you have finished the first five areas. For

the sake of efficiency, you could, of course, paint area 6 at the same time as area 2, using the same paint mixtures. I recommend waiting and remixing the colors for area 6, however. It will be very good practice, and you will see how much you have learned because the colors will seem so much easier to mix at that point. The more experience you have in mixing color, the faster you will learn. It will not be wasted effort!

2. Set up your palette of pigments and brushes as suggested in chapter 4.

3. To start with, choose a color in your pasted-on sample. (Figure 9-12 shows the completed area 2.)

4. The first step is to *see* the color in order to name the hue. You can isolate the color and see it better by laying the small cutout square opening of your hue scanner in the center of your value wheel directly over the color. Ask yourself the three key questions:

- *What is this hue?* Name the source hue—one of the twelve color wheel hues. For example, the source hue might be red-violet.
- *What is the value level?* Now rotate the punched-out holes of your gray scale value wheel on the original color—the fabric or paper design in area 1. When you find a value match for the color, *name* the value level—for example, it might be *medium value* (level 3).
- *What is the intensity level?* Refer to your intensity wheel for a comparison. Even though the colors are not the same, you will be able to extrapolate the intensity level of the original hue. Let's say it is *bright* (intensity level 2).

5. Once you have named the color by its three attributes (in our hypothetical example, red-violet medium value [level 3], and bright [intensity level

Fig. 9-12. Shows area 1, fabric; area 2, color match.

2]), you are ready to start mixing the color. Mix and test, mix and test, mix and test until you have an exact match.

6. Remember that acrylic pigments characteristically dry slightly darker than when wet, and allow for this in your mixture. Matching colors is challenging, but I think you will find it quite engaging.

7. When you have matched the first hue, paint it in the appropriate area next to same color in the pasted-on actual sample. Then choose the next hue to match and continue until you have matched and painted all of the hues in the original fabric or paper design (Figure 9-12, page 103).

Since you are painting directly adjacent to the original hues in your fabric or paper sample, you can easily determine if you have indeed matched each hue.

Fig. 9-13. Shows area 3, complements of the original hues, added to fabric match.

Area 3. Mixing and Painting Complements

You will need to keep your color wheel nearby for area 3 of your design, the direct complements of the original hues. For every hue in the original material you are working from, you will now find its *exact* complement, meaning the *complementary hue at the same value level and at the same intensity level*. Figure 9-13 shows area 3 completed on the demonstration design.

1. In matching the colors of the original fabric or paper design for area 2, you have already *named* each hue. Now, one at a time, use your color wheel to find each original color's *source hue* on your color wheel, then each complement—the color directly across the wheel from that hue. For example, if the original color's source hue is red-violet, the complement's source hue is yellow-green.

2. On your palette, mix the complement (in our example, yellow-green) by adding permanent green to cadmium yellow light to make yellow-green.

3. Now you need to adjust the value and intensity levels to match those of the original hue. If the full three-attribute name of the original color was red-violet, medium value (level 3), and bright (intensity level 2), then the direct complement will be yellow-green, medium value (level 3) and bright (intensity level 2).

4. Mixing on your palette, adjust the value level first by adding white to your yellow-green mixture to bring it to value level 3 (medium). Use your value wheel to check the correctness of the value.

5. Next, you will need to lower the intensity of your yellow-green mixture on your palette by adding red-violet, the complement of yellow-green. Mix a small amount of red-violet by adding cobalt violet to alizarin crimson. Add the red-violet in small increments to your yellow-green mixture until you reach level 2 intensity. (Check for level 2 intensity by first looking at your intensity wheel and then imagining an intensity wheel with pure, bright yellow-green at 12 o'clock dulled to no color at 6 o'clock by adding its complement, red-violet.) In your minds' eye, compare your mixture to level 2. (This sounds more difficult than it is—try it!)

6. Paint a test swatch of the medium value, bright yellow-green on a scrap of board, hold it next to the original color, and compare the two hues. If you have achieved a truly exact complement—that is, if you have the hue at the exact complementary opposite, with the value and intensity the same as the original color, the two colors will look beautiful together.

7. Use your yellow-green mixture to paint the appropriate area of your design. Then mix and paint each complement in turn until you have completed area 3 (Figure 9-13).

Fig. 9-14. Shows area 4, opposite values, added to previous areas.

Mixing these hues is great experience! Every bit of it will stand you in good stead later on when you are confronted with a color problem. If the work seems to go slowly, be patient with yourself. With practice, mixing complements will become rapid and automatic.

Area 4. The Opposite Values of the Original Hues

In this area, you will transform the original colors of the fabric or paper design in area 1 to hues that are *opposite* in value. Now that you have completed exact matches and exact complements, there is a little leeway for deciding on the opposite values and intensities. Some subjective judgment comes into play for these hues. You can begin to trust your eye in estimating the *same* and *opposite* value and intensity levels. Figure 9-14 show area 4 completed on the demonstration design.

If one of the original hues is, say, dark bright blue, you will paint the same hue, at the same intensity, but at the opposite value. Dark bright blue would become *light* bright blue in area 4. If one of the original hues were pale dull violet, the opposite value would be *dark* dull violet. (Note that the opposite of medium value is also medium value—that is, the value doesn't change. Look at your value wheel to see that value level 3 and value level 9 are the same.)

The general rules for lightening and darkening hues are as follows:

- To make hues lighter, add white.
- To make hues darker, add black.

1. For area 4, determine the opposite value of each original hue in turn by first consulting your value wheel.
2. On your palette, lighten or darken each original hue until you have reached the opposite value. For example, a very light hue will become very dark.
3. Paint these hues in the appropriate spaces of area 4 (Figure 9-14).

Area 5. The Original Hues at the Same Value Levels But *Opposite Intensity* Levels

At this stage of the exercise, I'm sure you are catching on that the key to color expertise is knowing what color is needed and knowing how to achieve it. Now, in area 5, you will paint some truly beautiful low-intensity colors that will function as deep, resonant elements in your color harmony (or high-intensity colors if, as in the demonstration design, the original hues were dull).

Students often do not like low-intensity (dull) colors. (If you look back at your painting for exercise 1 on page 45, "Colors I Dislike," and student examples on pages 97–99, you are very likely to see dull, low-intensity colors.) But in a painting that also includes some light and bright color, dull colors are often the essential anchors of a painting—just as bass notes in a musical composition anchor the lighter, higher notes.

In this area, you will paint colors that are the same in hue and value as your original colors but are the *opposite* in intensity. Figure 9-15 shows area 5 completed on the demonstration design.

1. First, name the hue by its source hue, value level, and intensity level. Let's use as an example green, light (value level 2), and bright (intensity level 2).
2. Next, name the hue that has the same source hue and the same value level, but the *opposite* intensity level: green, light (value level 2), and dull (intensity level 8, the opposite of level 2 on an intensity wheel).
3. To mix this hue, start with permanent green; carefully add small amounts of white to lighten the green to value level 2.
4. Then, dull the light green (lower the intensity) to intensity level 8 by adding cadmium red, the complement to permanent green.

Fig. 9-15. Shows area 5 completed, opposite intensities.

5. Now paint your light, very dull green in the appropriate space in area 5.

6. Continue to transform the intensity levels of each of your original hues, thus completing area 5 (Figure 9-15).

In the example given above, level 8 intensity is only two steps up from no color at 6 o'clock. Take another look at your intensity wheel to see what level 8 intensity looks like and check to make sure that your light dull green fits that level of dullness. This sounds harder written in words than it actually is in practice. You can trust your eye to make these determinations. The human brain/mind/visual system is very good at estimating opposites!

If you are receiving objections from your verbal mind ("This is too complicated!"), try to quiet your mind and continue working with one hue after another until this area is completely finished. Remember that you are training your eye to make precise discriminations in hue, value, and intensity, and you are training your verbal system to use the vocabulary of color to guide you through the mixing process.

Area 6. Return to the Original Colors

Area 6, the last outside area in your design, is the return to the original colors of your original fabric or paper design in area 1. Repeating the original colors helps to tie together the color arrangement, but the real purpose of this area is to provide practice in remixing the same colors you mixed at the start of the exercise. You may have already painted them (in order to save time and effort) when you painted area 2. If so, gaze at each color match in area 2 and area 6. If any color is off even slightly—too dark, too light, too bright, or too dull—I urge you to remix it and repaint the correct color match in both areas.

If you have waited (as I recommended) until you completed all of the other areas, you will be remixing the

original colors with a lot of color-mixing experience behind you, and I am sure you will feel the difference in the ease with which you complete this last area. Remixing the original colors will also give you a chance to correct any hues that have dried too dark or seem at all off-hue in area 2. Figure 9-16 shows area 6 completed on the demonstration design.

Fig. 9-16. Completed design.

1. For area 6, return your focus to the original piece of fabric or paper pasted onto area 1. If necessary, use your color wheel, value wheel, and intensity wheel to help you name in turn each of the original hues by its three attributes—hue, value, and intensity. You may find that, at this point, you don't need to consult your three wheels for every hue!
2. Determine the source hue for each original color.
3. On your palette, start with the source hues and adjust the values and intensities to match the original hues.
4. Paint each hue in the appropriate space of area 6 (Figure 9-16).

The Finishing Steps

I hope that you are pleased with your painting, just as my color theory students were pleased, and that you realize how fascinating color is, once you have learned the basics. You have only three small steps to finish your painting:

1. Carefully remove the masking tape from the edges of the illustration board.
2. Using pencil, sign and date you painting in the lower margin.
3. Finally, make a small diagram (see examples in Figures 9-1 to 9-5) of your design in pencil or pen on the back of your painting, designating each area:

 • The original fabric/paper design.
 • Matching hues.

- Exact complementary hues.
- Original hues at the opposite values.
- Original hues at the opposite intensity.
- Return to the original hues.

This small diagram will be a record of the learning you have achieved in this exercise. When you show your painting to friends and family, I assure you that you will hear such comments as, "Oh, I like that!" or "Oh, that's really beautiful!" or some equivalent response. These comments come from their aesthetic responses to your work.

Congratulations on finishing an important exercise! You have come a long way in getting to know color, and you now possess a basic knowledge of color that can be put to use in the next step: seeing the way colors are affected by light.

Fig. 9-17. An additional demonstration design. In this instance, the original fabric had mainly dull hues. Key: Area 1, fabric; Area 2, exact match; Area 3, exact complements; Area 4, opposite values; Area 5: opposite intensities; Area 6, return to the exact match of the original hues.

Fig. 9-18. Inset: A black-and-white photocopy provides a guide to the original values in your fabric.

10

Seeing the Effects of Light, Color Constancy, and Simultaneous Contrast

"A given visual phenomenon may not be perceived at all unless it is actively looked for."

Burnam, Hanes, and Bartleson, quoted in Rossotti, *Colour: Why the World Isn't Grey*

TO UNDERSTAND the three-dimensionality of forms, we see and use lights and shadows. These perceptions, however, are at an unconscious rather than a conscious level. We may see and consciously register, for example, that a man is wearing a light blue shirt, but we are not consciously aware that light falling on the shirt causes changes in the shirt's color, making it appear lighter on the highlighted folds and darker in the shadows of folds. We are also largely unaware that we are using the distribution of those lighted and shadowed areas to know the three-dimensional shape of the body beneath the shirt (Figure 10-1).

In learning to draw and in learning to use color, these perceptions rise to the conscious level: we see the shapes of lights and shadows, we see the color changes that light causes, and we become aware of how important these changes are to our comprehension of the shapes of things in

Fig. 10-1. The strong lights and shadows of the children's clothing define the underlying volumes of their bodies. Edward Potthast (1857–1927), *Beach Scene*, c. 1916–20, oil on canvas, 61 × 76.2 cm (24 × 30 in.). Hirshhorn Museum and Sculpture Garden, Smithsonian Institution, Gift of Joseph H. Hirshhorn, 1966, photograph by Lee Stalsworth.

our world. This awareness opens up new levels of perception and appreciation of light and color. For many people, learning to see how light affects color is a revelation similar to seeing the after-images phenomenon for the first time.

The Next Step: Seeing How Light Affects the Colors of Three-Dimensional Shapes

Thus far, you have learned the basics of color by working with colors as they appear in two-dimensional colored patterns. The challenging next step is learning to see how light affects colors in the real three-dimensional world—something that has been a passionate goal of artists worldwide. Even prehistoric painters, portraying animals on the walls of caves by using ochre for yellow, charcoal for black, and ground hematite for red (all mixed with animal fat to make pigments), varied the lightness and darkness of their colors to make the animals appear rounded and three-dimensional (Figure 10-2).

Fig. 10-2. This prehistoric horse was painted on the ceiling of a deep cave near Lascaux, France, about seventeen thousand years ago. It is called *The Chinese Horse* because it resembles horses painted in ancient China. Doc. V. AVJJOVLAT. Dept. Art Parietal—Centre de National de Prehistoire, France. The "Chinese Horse," Prehistoric cave painting. © Art Resource, N.Y., Lascaux Caves, Perigord, Dordogne, France.

Fig. 10-3. A high-key (pale) demonstration still life by the author, based on the complements blue and orange.

By painting a small still life made of folded colored papers set up to demonstrate how light falling on colors causes changes in hues, values, and intensities, you will put your color knowledge to use in seeing, mixing, and painting these subtle changes. Figure 10-3 shows an example of this exercise. Learning to see how light affects colors is particularly useful, since seeing and using color in everyday life requires that we deal with actual colors as they exist in our light-filled, three-dimensional environment. In doing this exercise, you will also put to use the knowledge you gained in the color transformation exercise (chapter 9) in how to balance colors across their attributes to make a harmonious color arrangement.

Why It Is Difficult to See the Effects of Light

In the introduction to her wonderful book titled *Colour: Why the World Isn't Grey*, British chemist and writer Hazel Rossotti wrote, "We must recognize...that color is a *sensation*, produced in the brain, by the light that enters the eye; and that while a sensation of a particular color is usually triggered off by our eye receiving light of a particular composition, many other physiological and psychological factors enter in." Two of the physiological and psychological factors that Rossotti refers to, of course, are color constancy (seeing only the colors we expect to see) and simultaneous contrast (the effects that colors have on each other). Just as these factors influence the way we see colors in general, they cause particular problems in trying to see the effects of light on colors.

When we look at an orange, for example, color constancy causes us to expect it to be orange-colored all over. Yet, an orange, placed under a bright light, may have an area on its orange surface (called the "highlight") that is almost white. On the shadowed side, the orange color may change to red-orange or dull brownish orange (Figure 10-4). The shadow the orange casts onto the surface it rests on will be a color that depends on the color of that surface. If the surface is white, the cast shadow may have an orange tinge caused by color reflected from the

Fig. 10-4. *Citrus Fruits.* S. Pearce/ PhotoLink. ©Photodisc.

orange onto the flat white surface. If the flat surface is colored, the shadow will combine that color and the orange hue reflected from the fruit. If there is a background of blue behind the orange, the blue may reflect on the rounded surface of the orange, causing yet another color change. Additionally, a blue background may cause us to see the orange as brighter than its actual color due to simultaneous contrast effects on the complementary hues blue and orange.

How to Accurately Perceive Colors Affected by Light

Over the centuries, artists eager to depict the effects of light on color have needed to find ways to *see past* color constancy and simultaneous contrast, and to see accurately those color areas changed by varying conditions of light. To accomplish this, they have invented numerous practical but unexpected methods (usually called "color scanning" methods or "spot scanning" methods) to perceive colors. The methods usually involve isolating a single hue by looking through a tiny opening in a device that blocks out surrounding colors that prevent clear perception.

Three Different Methods of Scanning a Hue

To help you begin to see how light changes hues on an object that is ostensibly a single color, an orange, you can experiment with the following variety of scanning devices. Expect to be surprised to find many changes in hue, value, and intensity on this relatively simple rounded surface. For the experiments, place an orange on a sheet of medium value, bright blue paper under a table lamp.

Version 1. The Curled Fist

1. Curl your hand into a fist, leaving just a tiny space through which to view the orange (Figure 10-5). In this way, you can isolate a small area of color—that is, visually separate it from its surrounding hues.

Fig. 10-5.

2. Closing one eye, bring your fist to your open eye and direct the tiny opening toward the orange. Scan slowly across the orange, looking for the lightest hue, the highlight. When you find it, hold your fist there, name the hue, and note the location.

3. Next, scan for the darkest hue on the rounded surface of the orange. Hold your fist there, name the hue, and note the location.

4. Then scan for the brightest orange hue, name it, and note its location.

5. Depending on where your light is located, you may find an area on the orange that is actually no color, because the blue of the ground plane has reflected blue (the complement of orange) onto the surface of the orange, thus canceling color. Scan the orange for such an area, most likely to be found on the underside of the orange or the shadow cast by the orange onto the blue paper.

6. Now, remove your curled fist from your eye and look at the orange with both eyes. Can you see the color changes where you noted them while scanning? This is difficult, because color constancy may negate the perceptions even though you have just seen them.

Version 2. The Paper Tube

1. Roll up a piece of paper to make a narrow ½-inch tube.

2. Close one eye and look through the tube at the orange (Figure 10-6).

3. Repeat the steps above, finding the lightest, the darkest, the brightest, and the dullest hues on the orange, again noting the location of the color changes.

4. Remove the paper tube and again try to see the color changes by overcoming color constancy—very difficult to do.

The nineteenth-century English painter J. M. W. Turner used a method of color scanning in landscape painting that must have caused some laughter among onlookers.

Turner would face away from the landscape view he was painting, bend low, and look at the scene through his spread legs.

In this way, he could see past his color constancy reaction to objects in his view and focus only on the perceived true colors.

Fig. 10-6.

Version 3. The Value Wheel/Hue Scanner

Your value wheel/hue scanner is the third device. The advantage of using this tool is that with it, you will be able to determine two attributes, hue *and* value. As with the first two devices, by looking at a color through the hue scanner (the small square opening in the center of the wheel), you can isolate a hue from the object it is part of, thus enabling you to bypass the effects of color constancy. In addition, isolating a hue from any surrounding colors enables you to bypass the effects of simultaneous contrast (the neutral pale gray you painted surrounding the small square opening in the hue scanner has the least possible effect on colors). Moreover, the punched-out holes in the outer rim of the gray scale allow you to determine with accuracy the value level by comparing the perceived hue with your value scale. Try it out as follows:

Fig. 10-7. Scan *hues* through the small square opening in your value wheel/hue scanner.

1. Take out your value wheel/hue scanner. Holding the wheel at about arm's length, close one eye and peer at the orange through the square opening in the center (Figure 10-7).
2. Slowly move the hue scanner across the surface of the orange, again looking for the lightest, darkest, brightest, and dullest hues and noting where they are located. Be aware that the source hue for each of these observed hues is orange. It is the values and the intensities of orange hue that change.
3. Now, direct the outside rim of the value wheel toward each selected area and look at each through the punched-out holes in the successive values, turning the wheel until you find the best match of values (Figure 10-8). Assign a value level for each separate hue that you see.

Fig. 10-8. Determine *values* by scanning through the punched-out holes on your value wheel. Turn the wheel until the value of a hue matches a value level on the wheel.

The Next Step: Estimating the Intensity Level

Now that you have learned to use your scanning device, the value wheel/hue scanner, the last step in identifying each

color change caused by light is to use your intensity wheel to determine *by extrapolation* the third attribute, the intensity level, of each of the three colors. Even though the basic colors you chose for your intensity wheel are no doubt different from the orange hues you are looking at, you can compare brightness or dullness and extrapolate the intensity level. There is some latitude in this estimation, and you can have confidence in estimating intensity levels between pure color and no color. This estimation of very bright, bright, medium, dull, or very dull seems to be not quite as difficult as determining value level.

1. Take out your intensity wheel.
2. Return your gaze to the hue scanner opening in the value wheel and compare each observed hue to your intensity wheel colors.
3. Estimate the intensity level of each hue as very bright, bright, medium, dull, or very dull. You can refine these observations by using the clock number designations: intensity level 1 (very bright), intensity level 2 (bright), and so on.

The Three-Part Process of Painting

Now that you have seen the effects of light on colors in your experiments with the orange, you are ready to see, mix, and paint the colors of objects as they are often surprisingly changed by light. In painting your still life, you will use the artist's time-honored method of gradual development of the painted image. Painting with acrylics or oil paints is not an immediate, all-at-once process. Rather, it is a process of stages, similar in some respects to writing, where you first make an outline of the main parts, then add details and particulars, and, finally, edit and refine what you wrote in the first stages.

The First Pass

In the first stage of a painting, often called "the first pass," you will rather quickly cover the white surface on the canvas or illustration board by painting all of the large color areas, carefully seeing, naming, and mixing the main colors as perceived in the subject being painted. Covering the white of the surface enables you to see the main colors without the simultaneous contrast influence of the bright white surface. These large color areas are the crucial and irreplaceable raw data for the painting, usually termed the *local color* or *perceptual color*.

The Second Pass

In the next stage, the second pass, you will return to each color area, looking more closely for slight changes in hues. These changes may be caused by colors reflecting on each other, by the effects of simultaneous contrast where two colors meet, and, most important, by variations in how light falls on various objects. Where light falls directly at right angles, you will find the brightest light and the lightest value of a given color (recall the highlight on the orange that was almost but not quite white). Where it falls obliquely, you will find a softer light. In addition, where objects in the still life block light rays, you will find shadowed areas. During this second pass, you will still be working with perceptual color—seeing, naming, mixing, and painting subtle changes in colors seen in the actual setup.

The Third Pass

In the final stage of your painting, the third pass, you will have a slightly different task—to see and use the colors that the subject provides, but also, in the final analysis, to attend to *pictorial color*—meaning that you will adjust the perceptual color of the setup into a color arrangement that is

coherent, balanced, harmonized, and *expressive* of your subject. The reason for this shift in emphasis is that the actual subject of a painting is nearly always ephemeral. If your subject is a still life, as in this instance, it will be deconstructed it as soon as the painting is completed. If the subject is a posed model, the model at some point will finish posing. If the subject is a landscape, the light and weather will soon change. The *painting*, on the other hand, lives on, and it is the painting, not the still life setup, the model's pose, or the particular landscape that we care about. Your job in this stage is to reconcile and perhaps edit any extraneous or unnecessary parts, to balance the color arrangement, and to bring the perceptual color into harmony with the pictorial subject and meaning of the painting. This dual task, to attend to both perceptual and pictorial color, exists no matter what the subject matter or whether a work is realistic or abstract.

Exercise 11. Painting a Still Life

The still life you are about to paint is simply a piece of folded colored paper set into a background. This paper object will catch the light and create shadows. It may reflect color onto the background or the floor of the setup or absorb color from its surrounding hues, thus providing you with practice in all the characteristics of light that might appear in a more complicated still life. Figures 10-9 through 10-12 show demonstration and student examples of folded-paper paintings.

Materials Needed

For this exercise, you will need the following materials from your list of supplies on page 40:

- Pack of colored construction paper.
- A viewfinder, which you will cut from black construction paper. The outside measurement of the

Fig. 10-9. A double complementary color scheme (blue/orange and red/green) by instructor Lisbeth Firmin.

Fig. 10-10. A demonstration of a blue/orange complementary arrangement by instructor Brian Bomeisler.

viewfinder should be 9" × 12", with a cutout opening of 7" × 10" (Figures 10-12a and 10-12b).

1. Tape for fastening the black paper viewfinder to your piece of clear plastic, 9" × 12" × 1/16".

- A permanent marking pen to draw crosshairs on the plastic, dividing the 7" × 10" opening into four equal quadrants (Figure 10-12a).
- A nonpermanent marking pen to draw the still life on the plastic.

2. A lamp to light the still life setup.

Fig. 10-11. An analogous color arrangement by student Javier Valadez based on red, red-violet, and violet—then grounded in a dull orange.

Fig. 10-12. A complementary arrangement in blue-violet and yellow-orange by student M. Tadashi.

There are three steps to start this exercise: Setting up an arrangement of objects for the still life, drawing the still life on your illustration board, and painting the still life.

Step 1. Making the Setup

1. Clear a space on your worktable. You will need an area about two feet square.
2. Choose three colors from your pack of colored construction paper. Two of the colors must be complements; consult your color wheel if necessary to make sure you have two complementary colors. Choose any color (or white or black) for the third choice.

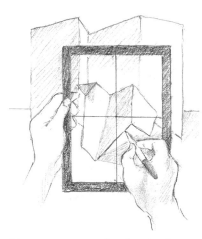

Fig. 10-12a. Use the plastic plane to compose your drawing and then sketch the setup with your felt-tip marker.

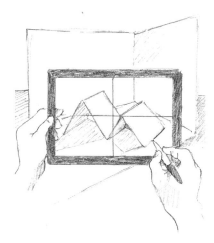

Fig. 10-12b.

3. Select one of the colored sheets to use as a "floor" for your setup and place it on your table.

4. Select another colored sheet to use as a background screen. With the long edges held horizontally, fold it once in the center. Then fold it once again into quarters so that you can stand it up on your floor color like a four-fold screen (see Figure 10-12a). If you prefer a simpler background, fold it once and stand it like two sides of a box (see Figure 10-12b).

5. The third colored sheet will be your still life object. Cut a strip about 16" × 4½". Fold this strip crosswise three times, so that it is folded like a fan. (See Figures 10-9 through 10-12, pages 122–23, and Figures 10-12a and b.) Place your folded paper object at an angle to your floor and background.

6. Place a lamp either to the right or to the left of your still life. Adjust the lamp so that some of the planes of the folded paper are lighted and some are in shadow.

Step 2. *Drawing the Still Life*

1. Use your low-tack masking tape to cover the edges of your 9" × 12" illustration board. The opening should measure about 7" × 10"—the same as the opening on your viewfinder. If you are unused to drawing, it can be easily accomplished by using your viewfinder/plastic plane to compose your drawing.

2. Using your ruler and pencil, *lightly* mark crosshairs on your illustration board to divide your format into four equal quadrants, just as you divided the plastic plane. Close one eye and look at the still life through the viewfinder moving it forward or backward, right or left, vertically or horizontally—just like taking a photograph—until you find a composition that you like. Figure 10-12a shows a vertical composition and Figure 10-12b shows a horizontal composition. By closing one eye, you remove binocular vision, the

two separate views that are melded in the brain to produce depth perception. The image you will paint needs to be flattened into two dimensions, like a photograph. Closing one eye accomplishes this flattening of the still life image by reducing your normal binocular vision, which provides three-dimensional vision, to monocular vision, meaning one view.

3. When you have found a composition that you like (trust your eye on this; most people are very successful at intuitively choosing good compositional arrangements within a format), uncap your felt-tip erasable marking pen. Holding the viewfinder very steadily with your nondrawing hand, again close one eye and use your marking pen to draw the main outlines of the setup directly on the plastic plane. Be sure to draw the shapes of the shadows (Figure 10-13). You will find that the angular shape of the object and the shadows it creates form an unexpectedly beautiful design. Be careful not to move the viewfinder or the position of your head. You need to maintain one view of the still life, just as though you were taking a photograph.

Fig. 10-13. Draw the outlines of the still life on your plastic plane.

4. Next, use pencil to copy your drawing on the plastic plane onto your illustration board. Using the crosshairs makes transferring the drawing on plastic to your illustration board easy. Notice where one particular point of the folded paper object falls in one of the four quadrants of the plastic viewfinder. Make a mental note of where that point is in the quadrant and use pencil to mark that approximate point on your illustration board (Figure 10-14).

5. Check another point on the plastic and mark that point on your board. Continue until you have marked the key points of the still life. Then proceed to sketch the setup lightly in pencil. If your drawing is not precisely accurate, do not be too concerned. You are working on color right now, not drawing.

Fig. 10-14. The crosshairs will help you copy your drawing on the plastic plane onto your illustration board.

Fig. 10-15. The first pass establishes the main color areas and covers most of the white surface of the board.

Step 3. *Painting the Still Life*

The First Pass

1. Take out your painting supplies and set up your palette of pigments.

2. During this exercise, you will need to see, name, and mix approximately eight to ten main hues, mixing each hue in succession as you work through the painting:

 - Two for the background color
 - Two for the floor color
 - One for the shadow color
 - Two to three for the folded paper object

3. Identify, mix, and paint the main colors in the setup, completely covering the white of the illustration board (Figure 10-15). Use your hue scanner (the small square opening) to see and name the source hue of each main hue in the composition. Use the value wheel to determine the value level of each hue. Use your intensity wheel to help you extrapolate the approximate intensity level. These main colors are the basic perceptual colors derived directly from the hues of the three pieces of construction paper, the folded paper object, and the main color changes caused by lights and shadows.

 - Note that you should try to be as direct as possible in mixing each color, avoiding aimless dabbing into many different pigments on your palette. At some point, such a mixture will inevitably cancel color into mud. For most mixtures, it is best to start with the source hue pigment, adjust the value by adding black or white, and then adjust the intensity by adding the complement. The exceptions are very pale hues,

Fig. 10-16. In the second pass,
you will look for and paint more
detailed and subtle perceptual
color changes.

where it is best to start with white, add the source hue, and then adjust for intensity.

The Second Pass

In this second pass, you will look for more detailed and refined perceptual color changes. They will be still based on the colors of the three sheets of construction paper, but tempered and revised according to the subtle changes you observe in hues, values, and intensities created by the light source (Figure 10-16).

1. Use your value wheel/hue scanner to check each area where you *think* you see a color change, perhaps where color is reflected from the folded paper object onto the background or floor area. Then move the small square opening of the hue scanner to an adjacent area. In this way, you can *compare the two hues* and really *see* if there is a difference between them. (Remember to close one eye and hold the hue scanner at about arm's length.)

2. Mix each slight change by adding white or black to change the value, or adding the complement to change the intensity of one of the basic colors, or by adding another hue if you see a reflected color. You will need to look closely, eyes squinted half shut, to see slight variations in the main colors—an area, for example, where the color of the folded paper object is reflected onto the background color, or perhaps where the background color is reflected onto the object or on the floor color.

3. Once you have identified a color change, decide what you need to add to your basic color for this area in order to match the color change. If you see an area of reflected color, add that color to the original hue for that area, mix and paint this slightly altered hue in the area where you saw it.

"Every hue throughout your work is altered by every touch that you add in other places."

John Ruskin, quoted in Rossotti, *Colour: Why the World Isn't Grey*

Fig. 10-17. In the third pass, you will bring each color into balanced and harmonious *pictorial* relationship with all the colors in your painting by adjusting hues, values, and intensities.

4. Continue to see, name, mix, and paint these subtle color changes until you are satisfied that you have found and painted most of them.

The Third Pass

Your still life painting now needs adjustment of its perceptual color in order to achieve a balanced and harmonious *pictorial* color arrangement, just as you adjusted and balanced the original hues in the color transformation exercise in chapter 8. As you have learned, the after-image phenomenon indicates that the brain seems to long for the exact complement of each color in terms of hue, value, and intensity. A viewer of your painting will be seeking this balance and will be grateful if you provide it.

In terms of instruction, this is a difficult procedure to explain. It is, however, something that every experienced painter becomes used to—the point at which you are working on the painting itself to bring it into coherence and harmony. You can trust your intuitions to a certain extent, but more important is the knowledge you have gained about "locking in" a color arrangement by means of manipulating and transforming hues relative to their three attributes. As a rule, this is not a time to introduce any entirely new and different color into your composition at this stage. Instead, try manipulating the values and intensities of hues already in your painting, as suggested below and shown in the demonstration painting (Figure 10-17).

1. Take another look at your still life painting. Look at each major color in turn *in relationship to the whole color arrangement*. Ask yourself the following questions, making sure that you check your decisions for changes against the perceptual color of the actual setup. You may be surprised to find that the needed color change is there in the setup and that you missed seeing it.

"The painter has two quite distinct systems of color to deal with—one provided by nature, the other required by art—perceptual color and pictorial color. Both will be present and the painter's work depends upon the emphasis he places first upon the one and then upon the other."

Bridget Riley, "Color for the Painter," 1995

Fig. 10-18. The high-intensity yellow in this painting "pops out" of this composition. At some point you may enjoy experimenting with such discordant colors, but your experiments will be based on knowledge.

- Have you varied the value range of each hue? (Check your painting *and* the still life for opposite values for each major color and adjust hues if necessary.)
- Have you included a low-intensity area for each hue? (Check for opposite intensities for each major color and adjust if necessary.)
- Is there any hue that seems "out of harmony" with the rest of the colors—that is, a hue not

anchored in the original main colors of the composition? (These hues will seem to "pop out" of the composition. See Figure 10-18 for an example of such a hue. If you find such a hue in your painting, repaint the area.)

- Is there any color that seems too dark or too starkly white for the rest of the color composition? (If so, adjust the value by adding black, white, or a colored glaze—pigment thinned with water to make it transparent.)

2. Deciding whether a painting is finished is always difficult. A good way to decide is to prop it up and look at it from a distance of about six feet. Squint your eyes to see if any color seems out of place, too light, too bright, too dark, too dull, or somehow just *wrong*. To double-check any questionable area, turn your painting upside down. If an area is wrong, it will seem even more wrong upside down. Try this upside-down technique with Figure 10-18.

3. When you have made the necessary revisions and you are satisfied that everything seems to fit in your painting, carefully remove the tape from the edges to reveal the surrounding white margin. This self-frame provides a boundary to the painting and a setting for the color arrangement. Sign and date your painting.

I feel sure that you will be pleased with this still life painting and with your progress in seeing how light affects colors. I urge you to show your work to friends and family for some much-deserved praise. One might say that the true subject is not the folded paper object set against certain background colors. The true subject is *light*, the depiction of which has engaged artists for centuries.

CHAPTER 11

Seeing the Beauty of Color in Nature

Fig. 11-1. *Allium albopilosum*: Large globes of eighty or more one-inch flowers in bright red-violet with yellow-green centers. The two colors are exact complements in hue, value, and intensity.

MANY COLOR EXPERTS agree with the saying that in terms of combining colors, "Nature always gets it right," meaning that they perceive nature's color combinations to be unfailingly harmonious. In this book, I am defining color harmony as color combinations that satisfy the brain's apparent longing for colors that are balanced by their complements, as they are in nature, and varied in their values and intensities. Throughout the natural world of landscape, seascape, animals, birds, and fish, we find these balanced color combinations. Light and bright colors are blended with analogous colors and contrasted by complementary colors, and these bright hues are nearly always embedded in a context of abundant, restful low-intensity hues.

Color Harmony in Flowers

In your work so far with color, you have experienced the aesthetic satisfaction that results from balancing hues and you have seen how light falling on colors adds to the rich variations in value and intensity that are so pleasing. With your new understanding of color, you will find yourself recognizing satisfying color everywhere in nature—perhaps most vividly in flowers, where complementary colors and varied attributes are clearly evident, able to be appreciated at close range.

In any flower shop, you can observe nature's genius with color. You will see violet markings on yellow flowers, red-violet flowers with yellow-green leaves, dull red-orange flowers with dull blue-green leaves. On a single flower petal, you will see color values that range from pure white to the brightest red, perhaps echoed and contrasted by variegated green-and-white leaves. You will see intensity variations from bright orange at the tips of petals dulled to nearly black-brown at the flower's center. Figures 11-1 and 11-2 show just two instances of perfectly balanced color in flowers.

An example from my own garden will help make the point that flowers are ideal exemplars for my definition of color harmony. Figure 11-3 is a photograph of a plant I bought about fifteen years ago in a tiny two-inch pot without a label. I have never been able to discover its name or genus. It dies back each winter, and then, in spring, starting with some blue-gray knobs, pale stalks emerge and send forth paddle-shaped leaves, which grow four to a stalk and lengthen to about ten inches. The leaves are covered with a soft, silky feltlike surface, and the color, depending on how light falls on the leaves, ranges from almost white to a pale bright blue-green to a slightly darker, duller greenish blue. In June, tube-shaped flowers appear at the center of each leaf stalk. Each flower is covered with tiny silver hairs that provide the same luminescence to the flowers that the

Fig. 11-2. *Tulip viridiflora*: Bright dark red petals with bright dark green "arms," like brushstrokes. The foliage is edged in creamy white and the flower has an almost black-purple blotch at the center. Thus, the flower and foliage together present two sets of exact complements.

Fig. 11-3.

satiny hairs give to the leaves. The color of the flowers, a light red-orange like a pale natural coral from the sea, is the precise complement in hue, value, and intensity, of the light blue-green leaf color.

I believe it is this plant's perfect harmony of color combination that gives me such pleasure. Light falling on the leaves and flowers causes variations in the values and intensities of the two complementary hues—pale blue-green and pale red-orange—providing that mix of *opposite and closely related hues* that seems to entrance our human brain. If I try to imagine the flowers in another color—bright red or dark purple or yellow—or the leaves as dark green or yellow-green, those combinations seem somehow wrong, and I realize that, once more, nature has gotten the colors absolutely right.

Floral Painting in Art

Some years ago, I saw an exhibition of French Impressionist Claude Monet's last flower paintings, done in the final years of his long life. In an effort to enliven the presentation, the designers mounted huge color photographs of the flowers Monet had painted right next to his paintings. The colors in the photographs were garishly brilliant—more brilliant than the flowers themselves could ever have been, thanks to modern photographic color processing.

Next to these photographs, Monet's paintings looked almost drab. Many had been left unfinished, and, in my imagination, I could empathize with the artist's exasperation at the inadequacy of pigments to capture nature's beauty. Even so, his paintings exceeded in every way the color-drenched photographs, because the paintings were filled with Monet's human passion, effort, and intent to capture and emulate nature.

While nature undoubtedly evolved its balance of bright and dull, light and dark, analogous and complementary colors for complicated survival purposes, our human

Fig. 11-4. Jean-Siméon Chardin (1699–1779), *A Vase of Flowers*, c. 1760–63, oil on canvas, 43.8 × 36.2 cm (17¼ × 14¼ in.). National Gallery of Scotland, Edinburgh, UK.

brain apparently—for what purpose is unclear—evolved the capacity to respond aesthetically to nature's beauty and to emulate it in drawings, paintings, and sculpture. Human beings, at least as far as we know, are the only creatures on this planet that make images of things and other creatures that we see around us. Monkeys and elephants, if given paints, brushes, and paper, do apply paint to paper and seem to make deliberate color choices. No monkey or elephant, however, has ever drawn or painted an image of another monkey or elephant, or of any recognizable subject, and it

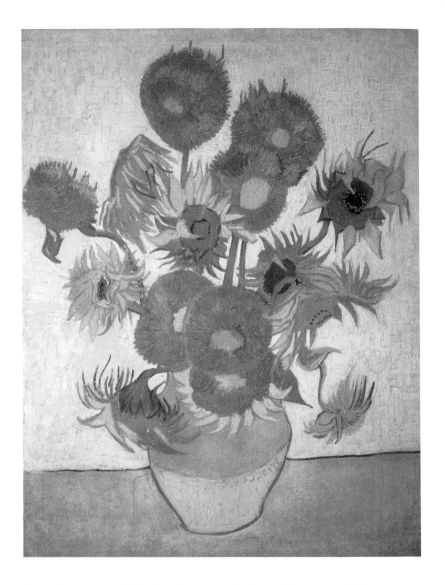

is at least possible that human beings alone are able to emu-
late our conscious pleasurable responses to the beauty of
the natural world.

Given this evolved aesthetic response, it is not sur-
prising that human enchantment with flowers goes back
to prehistoric times. Archaeological investigators have
found evidence that flowers were placed in some of the ear-
liest human gravesites. Our delight in flowers is especially
evident in art: floral decorations appear in artifacts of primi-

tive civilizations, and artists have depicted flowers from antiquity to modern times. Paintings such as *Sunflowers* by Vincent van Gogh are among the most familiar images of our time (Figure 11-5).

Colors in Nature Differ from Colors of Human-Made Objects

In the exercise that follows, painting a still life flower, you will be challenged and stimulated by a subject that provides the best possible practice for seeing and mixing beautiful, natural, harmonious colors. This exercise is challenging because, compared with the sheer brilliance and profusion of nature's colors, the pigments we must work with are quite limited and inadequate. A plant's colors come from such organic substances as chlorophyll, anthocyanins, carotenoids, and flavonoids, whereas most modern pigments come from a range of chemical, mineral, and purely synthetic materials. One must look at nature's colors carefully and with the utmost concentration in order to determine which of our pigment source hues and what variations in value and intensity will best approximate the perceived hues. You may be frustrated at times during the exercise that follows, but the aesthetic pleasure of seeing and responding to the beauty of natural colors will more than compensate your efforts. Remember, these color studies are just that: studies to enhance your understanding of color.

This exercise also gives you practice with a model that is alive. Even though it is a cut flower, it may move in response to your light source, it may drop a petal, or it may droop before you are finished. I recommend that you try to finish this painting in one sitting if possible, or two at most. This is good practice for the future, when you may wish to paint a person, an animal, or a landscape—subjects that may move and light that does change.

Movement by the model can become the nemesis of art students. In a figure painting class, one of my students suddenly threw down his brush, saying, "Well, that's it. I can't continue."

"What is the problem?" I asked.

"This model," said the student, "keeps breathing *in* and *out*."

Exercise 12. Painting a Floral Still Life

Materials Needed

For this painting, you will need the following materials (the same materials you used for the exercise in chapter 10):

1. Colored construction paper for the still life setup.
2. Your 9" × 12" piece of plastic with the taped-on black viewfinder and drawn-on crosshairs.
3. Your nonpermanent marker for drawing on the plastic.
4. A pencil and eraser.
5. A 9" × 12" illustration board with crosshairs drawn in pencil and the edges taped with ¾-inch artist's low-tack tape.

These flower paintings by the French artist Édouard Manet were painted during the last months of Manet's life. Though desperately ill, his spirits revived at the sight of flowers. "I would like to paint them all," he would say.

R. Gordon and A. Forge, *The Last Flowers of Manet*, 1986

Fig. 11-6a. Édouard Manet (1832–83), *Carnations and Clematis in a Crystal Vase*, c. 1882, oil on canvas, 56 × 35 cm (22 × 13¼ in.). Photo: H. Lewandowski, © Réunion des Musées Nationaux/Art Resource, N.Y., Musée d'Orsay, Paris, France.

Fig. 11-6b. Manet, *Flowers in a Crystal Vase*, 1882, oil on canvas, 32.6 × 24.3 cm (12⅞ × 9⅝ in.). Ailsa Mellon Bruce Collection, Image © 2003 Board of Trustees, National Gallery of Art, Washington, D.C.

Fig. 11-6c. Manet, *Bouquet of Flowers*, 1882, oil on canvas, 54 × 34 cm (21¼ × 13⅛ in.). Oskar Reinhart Collections "Am Römerholz," Winterthur, Switzerland.

6. Your pigments, brushes, and water.
7. Scrap pieces of illustration board to test colors and paper towels.
8. A fresh flower (or several flowers, if you prefer), a small vase, and a lamp. You may also add a single piece of fruit (a lemon, orange, or apple), if you wish. In the instructions, I will assume you are using a single flower in a vase.

As with any still life painting, the process is in three steps: (1) setting up the still life, (2) sketching the setup onto a painting surface, and (3) painting it.

Step 1. Setting Up

1. Find a stemmed flower that appeals to you as a subject for painting. The flower can be any color, but try to find one that has rather large petals—a tulip, for example, or a daffodil, rose, magnolia, or lily. This kind of flower provides better practice in seeing and mixing colors than a flower of many small petals where the hue, value, and intensity changes on each petal are on a very small scale and therefore more difficult to see— thus increasing the temptation to generalize color into "all yellow petals" or "all pink petals."

2. Cut the flower's stem fairly short, perhaps six to eight inches, leaving on a few leaves. Find a container that is in good scale with your flower. The container should be clear glass: it can be a simple glass vase, a small bottle, or even a water glass. Fill the container halfway with water and arrange the flower in it.

3. From your pack of colored construction paper, choose two colors: one that is analogous (adjacent on the color wheel) to the source color of your flower, and one that is complementary to it (opposite on the color wheel). Refer to your color wheel to determine these choices (Figure 11-7).

Fig. 11-7. The setup for your flower painting.

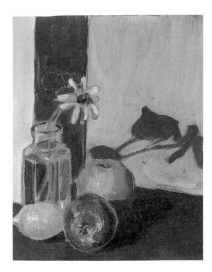

Fig. 11-8. A demonstration painting by instructor Brian Bomeisler. The color arrangement is based on double complements: red/green and yellow-orange/blue-violet.

Fig. 11-9. A demonstration painting by instructor Lisbeth Firmin. Again, the color arrangement is based on double complements: red-violet/yellow-green and blue/orange.

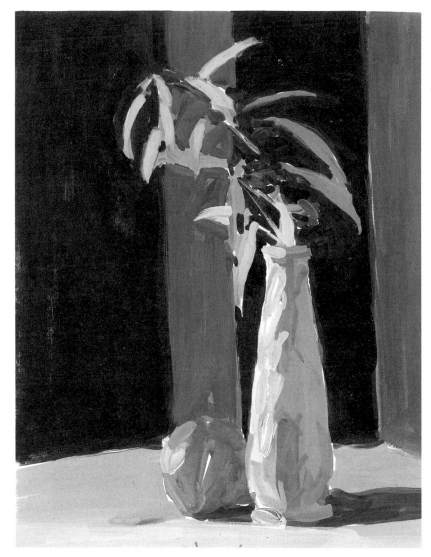

4. Use the analogous-colored paper beneath the vase as a base color for your still life. Fold the complementary-colored paper in half, then in half again. Open it like a four-panel screen and place it, standing upright behind the vase and flower, as a background. Light your still life with a lamp placed either to the right or to the left of the setup, making sure that the shadows cast by the flower and its vase add interesting shadow shapes to the composition. Figures 11-8

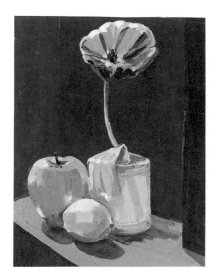

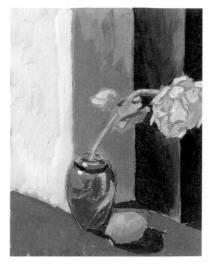

Fig. 11-10. A painting by student Jocelyn Eysymontt, using high-intensity complements red/green and blue/orange.

Fig. 11-11. A demonstration painting by Brian Bomeisler with low-intensity reds and greens and high-intensity blue-violet and yellow-orange.

through 11-11 are examples of the exercise by students and instructors. Figure 11-12 shows a sketch of the setup for my demonstration painting.

Step 2. Sketching the Still Life

In this step, you will sketch the still life onto your illustration board, again using your viewfinder and plastic plane as a drawing aid to simplify the process.

1. First, decide on your composition by closing one eye, holding up the viewfinder, and looking at your setup through the opening. Move the viewfinder back and forth, up and down, until you find a composition that you like. The flower and vase should occupy at least two-thirds of the opening of the viewfinder. You can cut off the bottom of the vase by the edge of the viewfinder if you wish. If you decide to include the whole vase, make sure that the bottom of the vase is at least ½ inch above the bottom edge of the

Fig. 11-12. Use your plastic plane to draw the main contours of your flower still life.

Fig. 11-13a. Piet Mondrian (1872–1944), *Chrysanthemum*, 1908, charcoal on paper, 78.5 × 46 cm (40 × 18⅛ in.). Collection of the Gemeentemuseum Den Haag, the Netherlands.

Fig. 11-13b. Mondrian, *Chrysanthemum*, 1908, gouache on paper, 94 × 37 cm (37 × 14½ in.). Collection of the Gemeentemuseum Den Haag.

Dutch artist Piet Mondrian revised his composition between the drawing and the painting of the chrysanthemum. By cutting the right side, the flower becomes more central and the composition more balanced.

opening in your viewfinder to avoid its appearing to rest on the edge of your painting.

2. Once you have decided on your composition, hold the viewfinder firmly and, remembering to close one eye, use your nonpermanent marking pen to draw the main parts of the composition onto the plastic plane, making sure to include any major shadow shapes (Figure 11-14).

3. Using pencil, transfer your drawing on the plastic to your illustration board, using the crosshairs as guides for placing each part of the drawing.

Step 3. *Painting the Picture*

Painting a Ground Color

As in painting your still life of the folded paper object in chapter 10, you will also build this painting in three stages, but with one change. In the previous exercise, you worked directly on the white ground, as many artists prefer to do. Other artists, however, prefer to use a grounded surface.

For this floral still life, you will begin by painting the entire white surface of your illustration board with a ground color, a neutral shade that is painted thinly enough for your pencil drawing to show through (Figure 11-15).

The ground coat accomplishes two things. First, it eliminates the stark white surface of the illustration board, which can cause problems of simultaneous contrast. Second, a thinly painted ground coat helps to unify your color by providing a subtle undertone for all subsequent hues. If you wish, you can allow bits of the ground to show through painted areas. This will also help to unify the color by providing small repetitions of the ground color throughout your painting.

1. Mix a neutral color of light-to-medium value and medium intensity to use for a ground coat. It might be a light gray made with white, black, and perhaps some orange to warm the gray. Or it might be a dull, pale yellow (white and yellow, dulled with violet), or perhaps a middle value, dull blue-gray (white, ultramarine blue, and black, dulled with a bit of orange). For the demonstration painting, I used a middle value, dull orange.
2. Mix your ground color on your palette, add water to thin it, and paint a transparent, thin coat onto the illustration board, allowing your pencil sketch to show through.
3. Allow the ground coat to dry before proceeding with your first pass.

Fig. 11-14. The main contours of the still life are drawn on the plastic plane using your felt-tip marker.

Fig. 11-15. For my demonstration painting, I chose a middle value, low-intensity orange, for the ground coat.

Fig. 11-16. In the first pass,
I painted the main hues of each
area, allowing bits of the ground
color to show through.

The First Pass

For the first pass, you will need to mix approximately
eleven to fourteen separate colors. Mix each in turn, as
you work your way through the various areas.

- Two (or more) hues for the background color
 (each panel of the folded construction paper may
 be in a different light than the other panels).

- Two hues for the floor color (one for the lighted area, one for the area in shadow).
- Three to four hues for the flower.
- Two to three hues for the leaves and stem.
- Two to three hues for the vase and water.

1. Choose one of the main color areas in your still life—one of the background hues, for example. Look at it through the square opening of the hue scanner and name it by its attributes. Then mix the color on your palette and paint the area.

2. Continue to identify the color of each large area of your still life and paint each in turn, until the entire background has been covered except for bits of the ground color that you have left to show through at the edges where two colors meet (Figure 11-16).

3. Next, turn your attention to the flower. Use your hue scanner to look at one petal at a time. Name, mix, and paint the main hue that you see on each petal. If, in scanning, you see two colors on one petal, decide which is the major hue, paint that, and leave the secondary hue for the second pass.

4. Scan your still life for the main hues of any additional flowers, fruit, or leaves, and then proceed to mix and paint those hues.

The Second Pass

In this second pass, you will continue seeing, naming, mixing, and painting the actual, pictorial colors you see out there, in front of your eyes, in the still life setup. Now, however, you will look closely for slight changes in values and intensities within the larger areas of the main colors. In making these adjustments to the relatively simple first-pass colors, you will achieve a greater range of related hues, values, and intensities.

1. Use your hue scanner to scan across each major background and floor area in turn, looking for slight

Fig. 11-17. In the second pass, I looked for more detailed and subtle changes in hue, value, and intensity in each area of the still life setup.

changes in hue, value, or intensity. Name, mix, and paint these new, smaller color areas. See Figure 11-17 for the second pass of my demonstration painting.

2. Look at the spaces, called "negative spaces," between the flower petals, the stem, and the leaves where the background color shows through. Do not just assume that these spots will remain the same background colors, because the light will change as it moves across the surface, and simultaneous

contrast may make these small areas appear lighter, darker, brighter, or duller. Use your hue scanner, value wheel, and intensity wheel to determine the hues in these negative spaces. Then mix and paint each hue in turn.

3. Focus next on areas of shadow. Your immediate impulse might be to mix black and white to make a gray shadow, but using your hue scanner will enable you to see the true color, or colors, of the shadows. A shadow may be a lower-intensity shade of the base color the shadow falls on, or it may contain a color reflected from the object that creates the shadow. A shadow's color may even be a complement of the hue around the shadow shape. These areas require that you minimize color constancy expectation and maximize accurate perception by using your scanning device. Name the hues, mix, and paint each shadow in turn.

4. Focus next on the flower petals to find the lightest areas, middle value areas, and low value areas. Be sure to look for changes in intensity as well. You may see three or four related values and intensities for just one petal. Even if your flower is white, you may find (with the help of your hue scanner) that some petals appear to be gray or green or violet (Figure 11-17). Scan the flower petals, and then name, mix, and paint hues.

5. For the leaves and stem, use your hue scanner to determine the exact green of the hue or hues of each leaf. In nature, there are thousands of shades of green, and in your still life the green of the leaves will be affected by the light falling on them, by color reflected from the background color, and perhaps by simultaneous contrast with the color of the flowers or the background (see Figure 11-9, page 142, for an example of simultaneous contrast: yellow-green leaves against a red-violet background). Name the hues, mix, and paint the leaves and stem.

Jane Eyre, teaching her young charge, Adèle, to draw:

"Remember, the shadows are as important as the light."

Charlotte Brontë, *Jane Eyre*, 1846

"The genius for inspired color relationships of certain painters of any period has no doubt been the result in part of a continuous mental analysis of color so informing and saturating the subconscious mind that every brush stroke of color is perfectly related to the whole color structure of the painting in all the dimensions of color."

Verity, *Color Observed*

6. To paint the vase, you will need to look closely in order to see the perceptual colors of the clear glass vase and the water inside it. These colors may come entirely from reflected background, floor, and flower stem colors. Carefully identify the color shapes with your hue scanner. They will be related variations but not precisely the same as the background colors. Name the hues, mix, and paint the vase and water.

7. Finally, look for some areas of highlights on the vase, the water, and perhaps on the leaves if they have a shiny surface. Use your hue scanner to determine the hue and your value wheel to determine the value of these highlights. They will be very light but probably not pure white. Name the hues, mix, and paint the highlights.

8. When you have found and painted all of the color variations in your setup, hold up your painting at arm's length next to the still life setup. Squint your eyes slightly and compare your color arrangement with that of the setup, looking for the following:

- First, look for the lightest hues in the setup and compare them to the lightest hues in your painting. Make any changes needed to make your pale hues match those lightest values in the setup.
- Look for the darkest hues in the setup and compare them to the darkest values in your painting. Make any changes needed to make your dark hues match those darkest values in the setup.
- Look for the brightest hues in the still life and compare the high-intensity colors in your painting. Make any necessary changes to match those brightest hues (this is difficult because of the limitations of our pigments).
- Look for the dullest hues in the setup and compare them to those in your painting. Make sure that your low-intensity hues are mixed from

complements and not by adding black to a hue. Make any needed changes so that your low-intensity hues match the colorfulness of the dull colors in the setup.

- Finally, compare the intermediate values and intensities in the setup with those in your painting and make any changes needed to match the values and intensities in the setup.

The Third Pass

Now is the time to look at your painting in terms of its pictorial color—that is, how well the color arrangement is working *as a painting*, aside from its function as a record of the perceptual or actual color of the setup. Your careful work in the first and second passes will pay off in this third pass. Since natural color is so often beautifully balanced, and since your subject is a flower, the perceptual color arrangement has a good chance of being harmonious without a lot of adjustment.

Remember, however, that in making the background and floor of the setup with colored construction paper, you added colors not of nature's choosing, and, by lighting the arrangement, you introduced another element of value and intensity changes. These added elements may need to be brought into balance with the flower's natural colors. In this pass, therefore, you will balance the pictorial color, the color combination within the four edges of your composition. Figure 11-18 shows the third pass of the demonstration still life. The first step is to take a long look at your work.

- Prop your painting up at eye level on a shelf or against a wall. Step back three or four feet and gaze at it, again squinting your eyes slightly. Ask yourself the following questions:

1. Do any of the lightest lights seem to pop out of the painting rather than staying anchored in the com-

"Only those who love color are admitted to its beauty and immanent presence. It affords utility to all, but unveils its deeper mysteries only to is devotees."

Itten, *The Art of Color*

Fig. 11-18. In the third pass,
I focused on all the interlocking
color relationships, trying to
bring all the colors into pictorial
harmony.

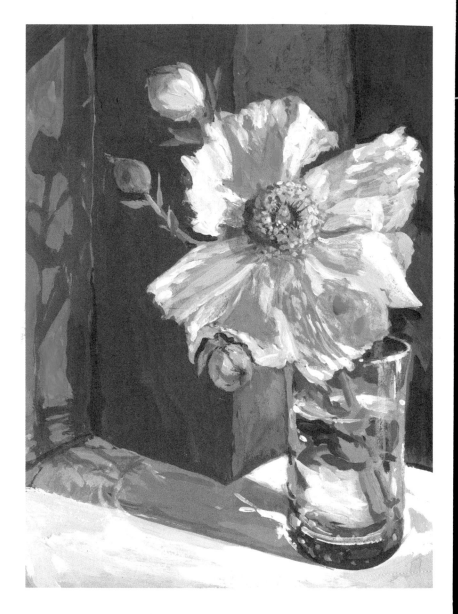

position? The highlights on the vase and water are
areas to look for a possible need to lower slightly the
value of the highlights. If so, make a mental note to
lower the value of the highlights, perhaps by thinly
glazing a tone over the white paint.

2. Do any of the darkest darks seem to carve holes in
 the color arrangement? Look especially carefully at
 the shadowed areas, which may need adjustment of

their values or intensities. If so, make a mental note to adjust the values where needed.

3. Is there any area of color that seems to fight for attention, which rightly should be centered on the flower? If so, make a mental note to lower the intensity or adjust the value of that area.

Next, focus on the composition—how all of the elements of shapes and spaces, lights and darks, as well as colors combine to form a balanced composition. Turn your painting upside down and again step away from it. If the composition looks just as balanced (though different) upside down as right side up, you can feel confident that the composition is balanced. If you have a vague feeling that something is off balance, or somehow "wrong," ask yourself the following questions:

1. Does the composition seem heavy on one side or the other, or at the top or bottom, or too empty in some area? Make a mental note of any questionable areas. Often these problem areas can be solved by slight adjustments of the value or intensity of the color in that area. One caution: This is not the time to introduce an entirely new color into your composition. To do so would require that all of the preceding hues be adjusted to accommodate the intrusive color.

2. Does something seem out of place, too bright, or too dull? In most instances, adjusting values or intensities of colors in these areas will solve the problem.

3. Finally, turn your painting right side up and check one more time the areas you noted in your upside-down viewing and make the changes needed to bring all of the colors into a balanced relationship with each other. This sounds much more difficult than it is. You can trust your intuitions on making these judgments. What *is* difficult is persuading yourself to take the time and make the effort to correct the problems (Figure 11-19, page 154).

Fig. 11-19. The finished painting, including the last minor changes and adjustments.

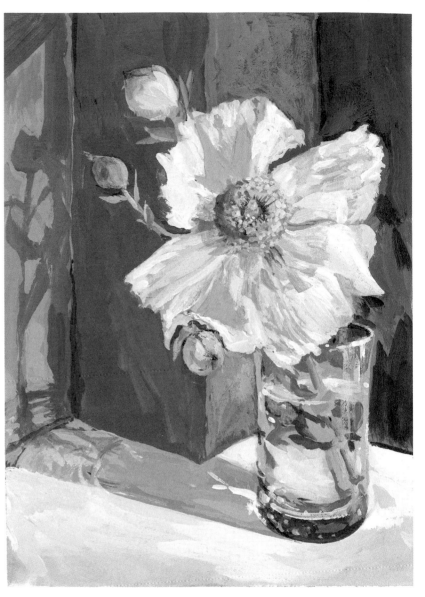

Matilija Poppy

Betty Edwards 7.3.03

Finishing the Painting

Now that you have brought the colors in your painting into a balanced relationship, you are ready for the final steps.

1. Carefully remove the tape on the edges of the board, which will provide a white boundary or frame for your painting.
2. If you wish to title your painting, write the title in pencil in the left bottom margin and sign and date the work in the bottom right margin.

Nature as a Teacher of Color

I hope you have experienced the special pleasure that comes from painting a live model like a flower and that you are pleased with your work. The effort of trying to match nature's matchless colors with our inadequate pigments is so great, it can only be justified by the satisfaction of having tried, and, through trying, having a greater understanding of color. Nature does not yield up her color secrets quickly, and because you had to radically slow down your perceptions to really *see* the colors in your still life the odds are that you saw in the flower color relationships you have never seen before. In addition, just knowing that you will be rewarded with a pleasurable aesthetic response if you take the time to see what you are looking at ensures that you will slow down your perceptions in the future.

You may be somewhat critical of your floral painting, suspecting perhaps that it is less beautiful than your model flower. In this feeling, you join thousands of artists over thousands of years. But remember: Your painting is important and beautiful because it is *your* unique and personal response to nature's beauty, something handmade by a human being enchanted by nature's colors.

CHAPTER 12

The Meaning and Symbolism of Colors

Artists' pure pigments, squeezed out of tubes onto a palette, become a rare instance of color existing as *color only*, unattached and unconnected to ideas, objects, or people. Upon seeing your freshly setup palette, perhaps you experienced that special response to the pure beauty of colors on a palette that many artists have noted in their writing. Of course, you then quickly put the pigments to use in the exercises and paintings, at which point thc colors became a means to an end. But for that moment before you started working with the pigments, color existed in its pure beauty, independent of connotation or connection. In almost every other instance, colors exist as part of something else and have acquired names and meanings through their connection with things, feelings, and concepts.

Attaching Names to Colors

In their exhaustive and extensively documented study *Basic Color Terms*, Brent Berlin and Paul Kay propose that as separate languages developed worldwide, color names entered each language *in the same order*. Black and white were the first to be named, followed by red. Next came green followed by yellow, or, alternatively, yellow followed by green. After that came names for blue, then brown, and finally purple, pink, orange, and gray.

In many cultures, even today, that short list is the extent of color names. In others, however, including American culture, there exists a huge vocabulary of both basic and esoteric color names—for example, teal, olive, coral, chocolate, sea-foam green, pumpkin, turquoise, and eggshell. This is a very recent phenomenon, however, possibly influenced by color television, color computer monitors, and—most ubiquitously—Crayola crayons.

In 1909, Binney & Smith Co. introduced Crayola crayons with a box of eight colors, named (clearly enough) *yellow, red, blue, orange, green, violet, brown,* and *black.*

In 1949, there were forty-eight, with still-recognizable names such as *red-orange* and *blue-violet.* By 1972, however, with seventy-two crayons, imaginative color names had proliferated to include *atomic tangerine, laser lemon,* and *screamin' green.*

Today, the Crayola box holds 120 colors, and some of the color names—*tumbleweed, razzmatazz, outer space,* and *manatee*—have meaning only for those under the age of twelve.

Fig. 12-1. Trarican Macur, Mapuche. Museo de Arte Precolombino, Santiago, Chile. Art Resource.

"The color symbolism of card packs—white, black, and red—is ancient and powerful."

Verity, *Color Observed*

Pervading all cultures and throughout history, people have attached meaning as well as names to their emotional responses to colors. Colors very quickly came to symbolize ideas, and researchers have found that the meanings assigned to specific colors were surprisingly consistent across cultures and across time. Some scientists have speculated that this consistency may indicate a universal color response structure in the human brain that is similar to the innate structure for language proposed by linguist Noam Chomsky.

Your paintings of the seasons in exercise 1, page 45, were first steps in using color to express ideas. As you may have found if you asked a friend to read your "Seasons" paintings, they are eminently readable, even though each person's color statements are quite individual (Figures 12-2 through 12-5 show examples of students' color statements). Color expert Johannes Itten said about his students' paintings of the seasons, "It is worth mentioning that though I have diligently sought opinions on my [students'] color representations of the seasons, I have never yet found anyone who failed to identify each or any season correctly." The following exercise is an experiment in using color to express additional subjective ideas.

Using Colors to Express Meaning

Now that you understand the structure and vocabulary of color and have used colors to depict things—the folded paper object in a lighted setting, and your floral still life—you can expand your focus to include color's expressive power and meaning in everyday life.

"The chief aim of color should be to serve expression as well as possible."

Henri Matisse

Fig. 12-2. Kathy S.

Colors I Dislike.

Colors I Like.

Summer.

Fall.

Winter.

Spring.

Fig. 12-3. Karen Atkins

Colors I Dislike.

Colors I Like.

Summer.

Fall.

Winter.

Spring.

Fig. 12-4. R. Larson

Colors I Dislike.

Colors I Like.

Summer.

Fall.

Winter.

Spring.

Fig. 12-5. Tim McMurray

Colors I Dislike.

Colors I Like.

Summer.

Fall.

Winter.

Spring.

Exercise 13. The Color of Human Emotions

In this exercise, as in your "Seasons" paintings, you will use color as a medium to express specific concepts. You will be painting within six small rectangular formats on a single piece of illustration board, each format assigned the name of a human emotional state or feeling (Figure 12-6). Within each format, you will depict no recognizable objects—no lightning bolts, no rainbows, no clenched fists, no smiley faces, and no daisies. You will also use no symbols—no stars, no numbers, no arrows, no words, no mathematical symbols. Color alone will express each concept.

Within each format, you may use one color, several colors, or many. You may use thick paint or paint thinned with water; you may leave some spaces unpainted or fill the entire format. You may mix colors or use pigments straight from the tube or bottle. *There is no right or wrong way to*

Fig. 12-6.

Anger. Joy. Sadness.

Love. Jealousy. Tranquility.

Fig. 12-7. First, tape the four edges of your illustration board.

Fig. 12-8. Next, center two vertical strips as shown.

do these paintings: the paintings you make will be right because they are right for you.

Try to do all six paintings at one sitting (the entire exercise should take about half an hour), and, if possible, find a quiet place where you will not be interrupted. Figures 12-12 through 12-15, on pages 166–67, show three students' paintings of "Human Emotions," but please wait to look at them until after you have completed your own paintings. In this way, you will not be influenced by the expressive colors of others.

1. Take out your painting materials. Set up your palette with all of your colors, including black and white, as described in chapter 4. You will need one of your 9" × 12" pieces of illustration board, your ¾-inch low-tack masking tape, and a ruler.

2. Turn your illustration board to a horizontal position, so that the long sides become the top and bottom. Apply a strip of masking tape to all four edges of the board (Figure 12-7). You will use three more strips of tape to mark off six equal sections for the paintings, as shown in Figures 12-8 and 12-9.

3. On the top edge of your board, measure 4 inches from the left side with your ruler and make a mark, then measure 8 inches and make a mark. Repeat the same measures on the bottom edge. Next, center two strips of tape on those top and bottom marks, thus dividing the board into three vertical sections (Figure 12-8).

4. Then add one more strip of tape, crossing the two vertical tapes at right angles to divide your board into six small formats (Figure 12-9).

5. Using pencil, write the title of each format directly on the tape, starting at the top left and going across each row, as in Figure 12-9.

6. Start with your color expression of "Anger." I have found that the best way to do these paintings is to

take each concept in turn and think back to a time when you felt that emotion. What color or colors *for you* seem to fit that feeling? Without preplanning the complete image, begin to paint. Work on the painting until you are satisfied that you have expressed the feeling. Do not hesitate to mix pigments to achieve your personal expression of a feeling.

7. Proceed next to the concept, "Joy," and continue until you have painted all six formats.

8. Carefully remove the masking tape, which will also remove the titles. Before you retitle each painting, give a friend a written list (in scrambled sequence) of the emotions you have painted and ask him or her to match the words to your paintings. You may be quite amazed at the accuracy of the matches made.

9. Finally, use pencil to rewrite the titles of each format under the paintings, then sign and date your work.

Fig. 12-10. Four students' expression of "Anger."

I have separated out four students' paintings of "Anger" and of "Sadness" (opposite) to demonstrate the seemingly broad agreement on color meanings.

Fig. 12-11. Four students' expression of "Sadness."

When you look at the student examples of "Human Emotions" paintings on pages 166–67, you may find some surprising similarities to your own paintings, as there seems to be broad agreement on color links to certain emotions. Anger, for example, seems widely linked to the color red, often with black added (Figure 12-10). This linkage shows up in our language with the phrases "I saw red" or "I was in a black mood." The concept of sadness often elicits shades of gray, violet, or blue (Figure 12-11). Tranquility often translates into pastel colors, whereas bright colors often represent the emotions of love and joy. Jealousy, clichéd though it seems, is often expressed in shades of green. Within this general description of expressive color, however, there is enormous variation from person to person, and you may find that your paintings reveal a uniquely individual color expressiveness.

The next step is to look at all of your paintings, including those from the last exercise, to discern your personal color preferences and your personal language of color.

Fig. 12-12. Kathy S.

Anger.

Joy.

Sadness.

Love.

Jealousy.

Tranquility.

Fig. 12-13. Nikki Jergenson

Anger.

Joy.

Sadness.

Love.

Jealousy.

Tranquility.

Fig. 12-14. Karen Atkins

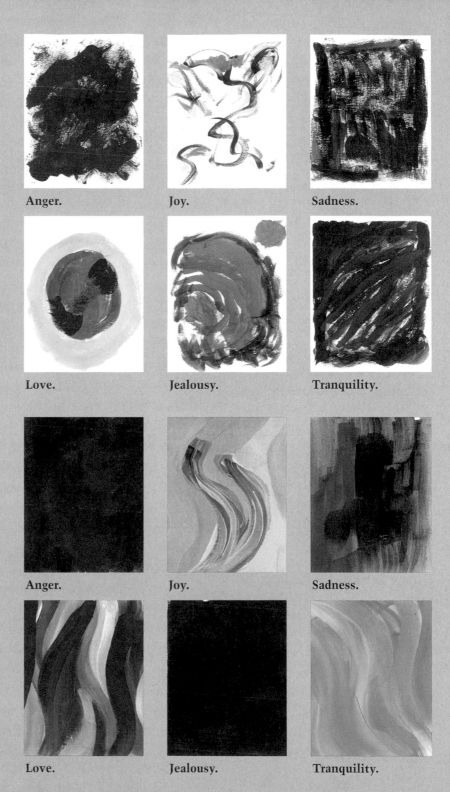

Anger.

Joy.

Sadness.

Love.

Jealousy.

Tranquility.

Fig. 12-15. R. Larson

Anger.

Joy.

Sadness.

Love.

Jealousy.

Tranquility.

Your Preferred Colors and What They Mean

During the course of this book, you have previously painted twelve exercises. Now, gather all of your paintings and spread them out on a table alongside your "Human Emotions" painting, the thirteenth exercise. Since the colors for your color wheel (Exercise 4) and your value wheel (Exercise 5) were specified, set those paintings aside. The color choices for each of the other exercises were your own, including choices of colored papers for the still life setups, and the flower color.

Therefore, this group of paintings can be said to represent, at least in part, your subjective color preferences and your personal color expression. It is well worth doing a brief written analysis of your personal color choices, so I suggest that you make a few notes to yourself on a sheet of writing paper in answer to the following questions about colors, values, and intensities. Or, you may prefer to make a chart similar to the one on page 169, or to photocopy the given chart.

1. **Preferred Colors**
 When you look at your group of paintings, do you find any repetitions of colors that appear first in your "Colors I Like" painting and then reappear in any of the subsequent work? List the most frequently used colors.

2. **Disliked Colors**
 Next, look at your painting "Colors I Dislike." Do these colors reappear in your "Seasons" paintings or in your "Human Emotions" paintings? If so, designate in your notes which colors reappear, and within which seasons, and which emotions. Among your other paintings, do you find any repetitions of colors you used in your "Colors I Dislike" painting? If so, list the colors.

Color preferences

	Main colors	Main value (light, medium, or dark: high contrast or low contrast)	Main intensity (bright, medium, or dull)	Main color scheme (complementary or analogous)
1. Colors I like				
2. Colors I dislike				
3. Spring				
4. Summer				
5. Fall				
6. Winter				
7. Color value wheel *(record color chosen only)*				
8. Color intensity wheel *(record color chosen only)*				
9. Color transformation exercise				
10. Still life with folded paper				
11. Still life with flower				
12. Anger				
13. Joy				
14. Sadness				
15. Love				
16. Jealousy				
17. Tranquility				

For obvious reasons, most people find many repetitions of the colors they like, and few find repetitions of the colors they dislike, but it is important to bring this aspect of your color preferences to your conscious attention. Also, of course, I am hoping that you have begun to appreciate low intensity colors for their value in harmonizing color combinations.

3. **Preferred Values**

 Is there a similarity in the overall value structures of your paintings—that is, are your paintings mainly light, mainly medium value, or mainly dark? If you discern a favored value structure, make a written note of this. Also note which of your "Human Emotions" paintings are dark, which are medium value, and which are light.

Among the student examples on pages 166 and 167, R. Larson's paintings (Figure 12-15) seem to show a preference for single values, often dark, with little contrast within each individual painting.

Conversely, Kathy S.'s paintings seem to show a preference for middle values, with fairly strong contrast within each painting.

4. **Preferred Contrasts**

 Do you find sharp *dark and light* value contrasts in you paintings, or are most of your colors in a narrow range of values? If you discern a favored contrast structure (high contrast or low contrast), write it down. Also, note which of your "Human Emotions" paintings show sharp value contrast and which do not.

5. **Preferred Intensities**

 Are your most frequently chosen colors mainly bright, mainly medium intensity, or mainly dull? If you discern a frequently used intensity structure, make a note of it. Also, note which of your "Human Emotions" paintings are bright, medium, or dull.

6. **Preferred Color Combinations**

 Have you used mainly complementary color combinations, or are most of your colors analogous (blending) colors? Note which of the two you used more

frequently, and, in addition, note where you used complementary or analogous colors in your "Human Emotions" paintings.

Knowing Your Color Preferences and Your Color Expressions

As you review your notes and read your paintings for their color expression, you can probably discern some general preferences, and perhaps even some decided preferences and dislikes. You might find, for example, that you used blue in nearly every exercise, that you seem to favor light values and bright, clear intensities, and that you prefer analogous color combinations.

With these combinations, the traits that come to mind (with awareness that one may be completely wrong) are openness, cheerfulness, and an outgoing personality. You may discover what your favorite colors tell you about your preferences for seasons and emotions, and, conversely, what your disliked colors indicate about possible aversions to certain seasons and emotions. You may find, for example, that the colors you like reappear in your "Spring" and "Summer" paintings, that the colors you dislike reappear in your painting of "Fall" or "Winter," and that these disliked colors reappear again in your expression of "Sadness" or "Jealousy."

On the other hand, you may find that red is a favorite color, that you prefer dark bright colors with many complementary contrasts, that your favorite colors reappear in your "Fall" and "Winter" paintings and in your expression of "Love," and that colors you dislike reappear in your expression of "Tranquility" or "Sadness." With these combinations, and with appropriate caution and skepticism, one might characterize the personality as passionate, intense, and active. There are infinite possibilities for combinations of color expressions that indicate traits, including the possibility that each of your paintings is different from all of the

rest, indicating an eclectic taste in color and no particular preferences or correspondences among colors, seasons, and emotions. The question that remains, however, is: "What do specific colors mean?"

The Symbolic Meanings of Colors

It is important to note that among color experts there are no hard-and-fast rules about color meanings, and while experts generally agree on broad meanings, there are many disagreements about the credibility of specific meanings. One of the complicating factors is that nearly every color has both positive and negative connotations, an ambiguity that does not fit well with scientific inquiry. Yet, we somehow know that colors are important to us in ways that are hard to pin down, and that the ambiguity of colors does not negate that importance. As Enid Verity puts it in *Color Observed*, "...color is recognized as a strong emotional factor in the lives of most normal people. Certainly the psychological and emotional aspects of color have the most popular appeal, and, although scientific and medical opinion may be skeptical of the rational validity of these aspects, the apparent universality of general interest, lends weight to what is essentially a subjective field."

With that caveat, I will briefly present some current opinions on the meaning and symbolism of the eleven colors that have names in most world cultures: red, white, black, green, yellow, blue, orange, brown, purple, gray, and pink. What follows is not intended to be a complete or scientific presentation of the meanings of colors but an overview of some general thoughts and cultural references. I hope that the information given might provide you with some valuable insights into the meaning of your own personal, expressive vocabulary of color. On a practical note, color self-knowledge will give you greater confidence in choosing colors for everyday life and certainly makes choosing colors more interesting.

For each of the colors discussed in the following section, remember that value and intensity changes modify meaning. Bright colors indicate intense emotions and pale colors just the opposite. Additions of other colors also change meaning. For example, as red moves toward orange or toward purple, or lightens in value toward pink, the meaning changes, taking on modifications related to the intermingled colors. Check below for the meanings of orange, violet, and pink to extrapolate the meaning of mixed colors.

Red

Of all the colors, the greatest agreement occurs on the symbolic meaning of red. Researchers tell us that red is associated with virility, stimulation, danger, and sexual excitement. Red is the color of blood, fire, passion, and aggression, the color that is the most violent and exhilarating. It is the color of war: Roman soldiers carried red battle flags, and many nations have clothed their soldiers in red tunics. In ancient Greece, actors wore red to symbolize the disastrous war in Homer's *Iliad*. Red is associated with the Devil, who is often depicted with bright red skin or wearing red clothes. A red flag represents a warning, and red tape—bureaucratic hindrance.

On the other hand, red is the color of the Christian church's Passion ceremony of the death of Jesus, and Christian priests often wear red chasubles to symbolize the shed blood of martyred saints. To the Russian people of the early twentieth century, the red flag of Soviet Russia signified revolution and freedom from the tyranny of the czars, but, as power-driven Russian leaders corrupted the ideals of the revolution, communism became the "Red Menace" to the Western world. On a softer note, brides in

Fig. 12-16. Jan Vermeer (1632–75), *Girl with the Red Hat*, 1665–66, oil on panel, 22.8 × 18 cm (9 × 7 in.). Andrew W. Mellon Collection, Image © 2003 Board of Trustees, National Gallery of Art, Washington, D.C.

Imagine how the effect of this painting would change if the hat were light blue or pale green.

China wear red, and in many cultures red is used as a burial color. In America, red means love, action, dynamism, and power (think of Valentine's Day, red-blooded Americans, and the American flag in which the red stripes have come to symbolize hardiness and valor).

Now, regard your own paintings from the standpoint of the symbolic meanings of the color red—specifically speaking, a very bright, medium value red. Does your use of red convey any of the meanings described above or have you used red in an altogether different way? It is probably safe to say that you were more likely to use red to express "Anger" than to express "Tranquility."

White

White evokes contradictory interpretations. In Western cultures, for example, white symbolizes innocence and purity (think of a bride's gown or a baby's baptism dress), but in many other cultures—Chinese, Japanese, and many African nations—white represents the color of death. The Chinese wear white clothing to funerals to honor the purity of the departed soul, but a white mask in Chinese drama signifies a frightful person. A curious echo of the latter meaning is our own representation of ghosts as white. The white whale in Herman Melville's *Moby-Dick* is perhaps the most sinister evocation of white in American literature, and a white feather in British folklore signifies cowardice. On the other hand, a white flag of truce signals an honorable intent to surrender peaceably. In the ancient symbolic meaning of colors in dreams, white meant happiness in the home, which brings to mind all of those detergent commercials that shout the importance of white.

Fig. 12-17. John Singer Sargent (1856–1925), *The Fountain, Villa Torlonia, Frascati, Italy*, 1907, oil on canvas, 71.4 × 56.5 cm (28 × 22¼ in.). Collection, Art Institute of Chicago, Friends of American Art Collection, 1914.57.

In this painting, Sargent's use of white conveys a sense of luxury and leisure.

Regard your own paintings in terms of these meanings of white. If you chose a white flower for your floral still life, for example, that choice may carry a connotation of purity since, in the Christian faith, the white lily symbolizes the Madonna. A viewer of your painting probably will not be consciously aware of that connotation, but these deeply embedded color meanings are likely to be there in the viewer's subconscious mind. The negative connotations of white may appear in your "Seasons" or "Emotions" paintings.

Black

In the Western world, black connotes death, mourning, and evil, and a liberal use of black has negative overtones as the color of ill omen, hell, and damnation. In old western films, the black hat and white hat were the symbolic headgear for the "bad guys" and the "good guys." For the ancient Egyptians, however, black (the color of the Nile Delta soil) meant life, growth, and well-being. In our own time, the African-American "Black is beautiful" campaign urges a return to this more positive orientation toward black. Black has always been associated with night (the absence of light), and, for this reason, is also associated with unknowing, mystery, and intrigue. Perhaps that association explains the preference for "basic black" as a sophisticated fashion statement in clothing and the fear of black cats crossing one's path. In the Western world, black became the color of the clergy and, at the same time, the color worn by widows and graduating college students.

Regarding your paintings, do you find a liberal use of black, or is it confined to specific themes of seasons and emotions? Black and white contrasts form the clearest of messages: good versus evil, right versus wrong, future versus past, success versus failure, good luck versus bad luck. On a scale of values, black also represents the lowest possible value, meaning the complete exclusion of light. Scan your paintings for your use of black and note down its frequency or absence.

Fig. 12-18. Ad Reinhardt (1913–67), *Painting*, 1954–58, oil on canvas, 198.4 × 198.4 cm (78⅛ × 78⅛ in.). © Ad Reinhardt, 1954–58/ARS. Licensed by VISCOPY, Sydney 2002.

"From 1950 until his death in 1967, Reinhardt purged his paintings of color, eventually arriving at his black paintings, the solemn, reductivist canvases for which he is perhaps best known."

Virginia M. Mecklenburg, 1989

Green

Color experts generally agree that green is the color of balance and harmony and symbolizes spring and youth, hope and joy. In Christianity, green is the color of new life, and is associated with baptism and the feast of the Eucharist. In the Muslim world, green signifies the Prophet Muhammad and therefore represents the entire religion. As Islam's sacred color, however, green is reserved as a special sign of respect and veneration. In England, the color "Lincoln Green" has a heroic connotation because of its connection with the folk figure Robin Hood. In the Western world, the "Go" sign is green, and "Think green" has become the byword for ecological preservation.

As with most colors, however, green has negative as well as positive connotations. Oddly, in view of its generally positive connotation of health and growth, green can also symbolize illness, as in the green of bile or in someone's being said to "turn green"—which comes from actual loss of the healthy skin color (perhaps due to the loss of its complement, red, from the "blush" of good health). It is also the color of envy and jealousy, especially in its less popular mixtures, such as intense yellow-green and olive green. Recall that in William Shakespeare's play *Othello*, Iago warned his master, "O, beware, my lord, of jealousy! It is the green-eyed monster..." Green also appears in oddities, such as "Little Green Men" from outer space and "The Incredible Hulk." As Jim Henson's creation Kermit the Frog said, "It's not easy being green."

Regard your paintings now in terms of the color green. Does its frequency indicate it is a favorite color, or is it confined to small areas and sparse use? Which of your "Seasons" paintings emphasize green? Does green appear as a major color in any of your "Human Emotions" paintings? Does your use of green carry negative connotations? Make a note of your use of green.

Fig. 12-19. Paul Gauguin (1848–1903), *Green Christ (The Breton Calvary)*, 1889, oil on canvas, 92 × 73 cm (36 × 29 in.). Musees Royaux des Beaux-Arts de Belgique.

For Gauguin, color signified mystery. In 1892, he wrote: "... we use it (color) not to define form, but to give musical sensations which spring from it, from its peculiar nature, from its inner power, its mystery, its enigma ..."

John Gage, *Color and Culture*, 1993

Yellow

Yellow is one of the most ambiguous colors. It is the color of sunlight, gold, and happiness, of intellect and enlightenment, but it is also the color of envy, disgrace, deceit, betrayal, and cowardice. In Islam, golden yellow is the color of wisdom, and during the Chinese Ch'ing dynasty (1644–1912), only the emperor was allowed to wear yellow. In the Christian tradition, however, Judas wore a yellow cloak when he betrayed Jesus with a kiss. In his book *The Primary Colors*, Alexander Theroux expounds the enigma of yellow: "So few colors give the viewer such a feeling of ambivalence or leave in one such powerful, viscerally enforced connotations and contradictions. Desire and renunciation. Dreams and decadence. Shining light and shallowness. Gold here. Grief there. An intimate mirroring in its emblematic significance of glory in one instance and, in yet another, painful, disturbing estrangement. An opposing duality seems mysteriously constant."

Reflecting this ambiguity, the Yellow Brick Road of L. Frank Baum's *The Wonderful Wizard of Oz* was paved in bricks of gold, but they symbolized the bitter congressional fight over the gold standard and tight money policies in the early 1900s. The Beatles' 1968 animated film, *Yellow Submarine*, was a lighthearted modern version of the ancient mythology of good versus evil. The yellow submarine symbolized youthful optimism, and the Blue Meanies, who despised both music and love, were the unsuccessful opposing force. Modern law enforcement uses bright yellow tape to mark a crime scene, another good-versus-evil sign. In the ancient symbolism of dreams, pale yellow meant material comfort, but deep yellow signified jealousy and deceit. Gentlemen are said to love blondes, but women with blonde hair were called—by those same gentlemen—"dumb blondes." On the other hand, yellow in nature is often extolled as

"I have always felt it significant, incidentally, that the enchanting autumnal forest in Robert Frost's poem, 'The Road Not Taken,' be autumnal, making the line, 'Two roads diverged in a yellow wood,' a prefigurement of a time when the speaker, though now young, will see how, when he gets older, choosing one road over another crucially matters."

Theroux, *The Primary Colors*, 1994

cheerful and charming, as in Wordsworth's 1804 poem "Daffodils":

> *I wander'd lonely as a cloud*
> *That floats on high o'er vales*
> *and hills,*
> *When all at once I saw a*
> *crowd,*
> *A host, of golden daffodils…*

In Jungian psychology, yellow symbolizes the flash of insight called "intuition," which seems to come "from out of the blue" or "from left field," which, incidentally, is the visual field of the right hemisphere of the brain.

Regard your paintings now in terms of your use of yellow. Like many people, you may be fond of yellow and see it only in its positive aspects. If so, yellow will appear among your favorite colors, preferred seasons, positive emotions, and in your still life paintings. On the other hand, shades of yellow may appear in your "disliked colors" and your painting of "Jealousy" or "Sadness."

Fig. 12-20. Brian Bomeisler, *Yellow Cross*, 1992, oil on canvas, 213¼ × 111¾ cm (84 × 44 in.). Collection of the artist.

Blue

Fig. 12-21. Pablo Picasso (1881–1973), *The Old Guitarist*, 1903–1904, oil on panel, 122.9 × 82.6 cm (48¼ × 35½ in.). Helen Birch Bartlett Memorial Collection, The Art Institute of Chicago.

In world languages, words for the color blue came long after words for black, white, red, green, and yellow. This is surprising in view of the fact that both sky and water are blue and that this blueness is visible nearly everywhere. In all of Homer's epics, with countless references to sky and water (as in "the wine-dark sea") there is no mention of the color blue. Similarly, with hundreds of references to the sky and heaven in the Bible, the word *blue* never appears. Perhaps this was because the early writers felt the color blue to be ethereal and insubstantial—essentially unreal, unlike the colors red, white, black, green, and yellow, which were viewed differently. Blue evokes the void or vast distances, as in something disappearing "into the wild blue yonder." "Blue is the color of the millennium [the twenty-first century]," according to a recent announcement by a color-prediction firm, the Color Portfolio. "It is serene and pure, like the ocean..."

In its darker versions, blue represents authority (the prototypical elected official's dark blue suit), and, in the symbolic meaning of colors in dreams, blue means success. Both the Ford Motor Company, founded by Henry Ford, the quintessential authoritarian manager, and IBM adopted blue as an identifying color. IBM came to be known as "Big Blue," linking it with the success aspect of the color. In its paler versions, blue means happiness. In Christianity, the Madonna is usually clothed in blue, symbolizing fidelity, as reflected in our modern phrase "true blue."

Yet, like other colors, blue is ambiguous and mysterious. Blue connotes reverie, sadness, and melancholy.

Picasso, in his "blue period" paintings, depicted the lowlife of Paris with its sadness and poverty (Figure 12-21). When Picasso's mood improved (along with his living conditions), he initiated his "rose period." And how many hundreds of sad songs have the words *blue* or *blues* in the titles? Enigmatically, blue signifies both immorality, as in "blue movies," *and* Christian morality, as in "blue laws," meaning laws to curb immoral behavior, and "bluenose," meaning an excessively puritanical person.

Regard your paintings now from the standpoint of your use of blue and the meanings described above. If, for example, blue appears in your painting of "Anger," it may mean that anger, for you, is related to authority and power. If it appears in your depiction of "Love," for you it could mean that love is boundless and vast, or, conversely, it could mean that love carries an element of sadness or "the blues." Scan your paintings for your use of blue and note any repetitions of blue in your depictions of the seasons, emotions, and the colors you like or dislike.

Why make so much
 of fragmentary blue
In here or there a bird,
 or butterfly,
Or flower, or wearing-stone,
 or open eye,
When heaven presents in sheets
 the solid hue?

Robert Frost, "Fragmentary Blue,"
1920

"Blue is a color that moves easily from reality to dream, from the present to the past, from the color of the daytime into the blue amorphous tones of deepest night and distance...In his *Farbenlehre*, Goethe called blue 'the color of enchanting nothingness.'"

Theroux, *The Primary Colors*

Orange

Orange is singular among the primary and secondary colors in that it seems to carry little symbolic meaning, though it is often used as an identifying color for sports teams, as in the uniforms of the Baltimore "Orioles," and, illogically, the new uniforms of the Cleveland "Browns" (although the helmets remain brown). Curiously, there is little mood or feeling connected with the color orange—that is, there are no phrases in our language about *feeling orange* or *being orange*, as there are phrases about feeling blue, being in a black mood, being yellow (cowardly), or thinking green.

Orange is related to heat and fire, but without the intense feelings ascribed to red and, as red becomes more red-orange in mixture, it loses its meaning of danger. The

The Color Marketing Group, an international association for color professionals, produces each year a "Forecast Palette" of fifteen to twenty colors with Crayola-like imaginative names. The 2003 predictions included these versions of orange:

"*Squash*: Representing the natural evolution of orange, this warm and comfortable, non–gender specific color bridges the age gap from youth to maturity."

"*Tangy*: A natural yet clear orange. Adventurous, daring color that rockets into space."

Fig. 12-22. Mark Rothko (1903–70), *Orange and Yellow*, 1956, oil on canvas, 231.1 × 180.3 cm (91 × 71 in.). Collection Albright-Knox Art Gallery, Gift of Seymour H. Knox, Jr., 1962.

Protestant Orangemen of Northern Ireland are passionate about the color, and Buddhist monks are highly visible in their saffron orange robes. Every decade or so, orange emerges as a fashionable color in clothing and furniture, as it did in the 1960s and the 1980s, and, according to the color prediction industry, it is back in favor again. Orange is connected to the fall season and to Halloween, and seems to carry some connotation of frivolity, lack of seriousness, or mischief, but on the positive side, perhaps, energy without aggression.

In light of the indefiniteness of orange, it will be interesting to scan your paintings for your personal use of orange, since it seems to have few distinct symbolic meanings. You may find that you used orange in conjunction with brown, which is actually a dulled orange, and which does have symbolic meaning, especially for the fall season.

Brown

The fact that brown is the color of the earth's soil probably explains why it is one of the few colors named in early languages (along with black, white, and pink) that is not a pure primary or secondary color. Brown is a low-intensity color made by mixing blue or black with orange. It is not surprising that brown is often regarded as a dreary color. It frequently symbolizes misery or gloominess, as in the phrases "in a brown study," meaning in deep thought, or "in a brownout," meaning loss of focus or ability to concentrate. The color of uniforms is often brown, as in Nazi Germany's Brownshirts, a particularly unsavory group. On a more

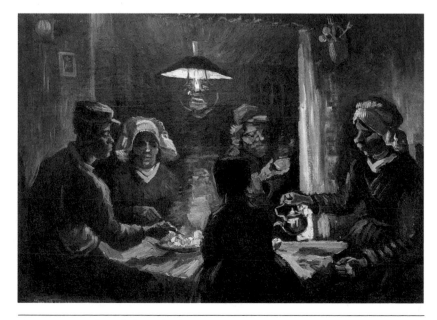

Fig. 12-23. Vincent van Gogh, *The Potato Eaters*, 1885, oil on canvas, 82 × 115 cm (32 × 45 in.). Vincent van Gogh Foundation, Rijksmuseum Vincent van Gogh, Amsterdam, the Netherlands.

In a letter to his brother, Van Gogh stated his aims for this painting: "...to emphasize that those people, eating potatoes in the lamplight have dug the earth with those very hands they put in the dish, and so it speaks of manual labor and how they have honestly earned their food."

The Complete Letters of Van Gogh

positive note, the Brownies in folk literature were small brown elves who helped with housework, and the sobriquet "Big Brown" now humorously identifies the United Parcel Service delivery vans. These links may provide insight into your personal use of brown.

In your paintings, it is likely that you used brown in some of the "Seasons" paintings, but it will be interesting to note whether you also used brown in any of the "Emotions" paintings or among the colors you like or dislike.

Purple and Violet

Purple is a dark color, the closest in value to black, and some of its symbolic meaning stems from the fact that it reflects so little light. Purple's complement, yellow, is the palest of the color wheel hues and the color that reflects the most light. Thus, the two together form something like sunlight and shadow (or perhaps, in emotional terms, joy and sadness).

Purple is a color associated with deep feeling, as in "purple passion" or "purple with rage." It is a color associated with mourning for the death of loved ones. In early cultures, purple dye was extremely difficult and expensive to produce. Therefore, "royal purple" quickly came to symbolize the ruling class, dignity, and power, and purple clothing was forbidden to those of lower rank. A "purple patch" in painting and in writing is a section that is overwrought and even lurid, but fondly clung to by the painter or writer. Purple connotes bravery, perhaps an extension of its connection with royalty, as with the "Purple Heart"— a heart-shaped purple-and-gold military medal on a purple ribbon signifying injury in battle. It is not difficult to imagine how the symbolism would change if the medal were, say, yellow instead of purple. Would any military person want a "Yellow Heart"?

Fig. 12-24. Pieter Brueghel the Elder (1529–69), *Parable of the Blind Men*, 1568, oil on canvas, 78.7 × 154.9 cm (36 × 61 in.). Galleria Nazionale, Naples.

Violet, in color theory, is interchangeable with purple. Both are made from red mixed with blue. In common usage, however, the term "violet" calls to mind a somewhat paler, softer hue, without purple's connection with authority and power. Violet has a slightly different connotation, one of sadness, fragility, and vulnerability. A "shrinking violet" is a shy, withdrawn person, and the phrase "the violet hour" refers to dusk, rest, and reverie.

Scan your paintings now and make a note of your use of purple and violet. It will be interesting to note whether you used the complements yellow and purple together in any painting, and if you have differentiated symbolically between deep purple and lighter violet.

"This sorry train, in its shadowless incorporeality, has a ghostly, unreal effect."

Itten, *The Art of Color*

Here violet represents false piety and blue-gray represents superstition.

Fig. 12-25. James Abbott McNeill Whistler (1834–1903), *Symphony in Flesh and Pink: Portrait of Mrs. Frances Leyland*, 1871–73, oil on canvas, 195.9 × 102.2 cm (77⅛ × 40¼ in.). © The Frick Collection, New York.

Color by Betty Edwards

Pink

Pink, although it is made from red mixed with white, has none of red's violent connotations. Pink is quite benign and generally symbolizes light moods. It is associated with girl babies, femininity, and cotton candy, although, in its "hot pink" version, it becomes more aggressive and sensual. During the 1950s, the word *pinko* was a derogatory term for left-leaning political views, and politicians, even today, avoid wearing pink ties. Illogically, however, politicians often wear red ties, a color even more highly charged relative to communism.

Scan your paintings and make a note of your use of pink. It could show up anywhere—in your depiction of "Love," obviously, but also in "Spring," "Tranquility," "Joy," or "Anger," where pink might temper the aggression of red, indicating a milder form of anger.

Gray

Gray is the color of gloom and depression. A Billie Holiday recording of the song "Body and Soul" has the lines, "What lies before me? A future that's stormy, a winter that's gray and cold." Gray is also the color of indecision and uncertainty—of "gray areas" that defy direct action. It is the color of ash and lead, and it is associated with aging, as in "the graying of America." It carries the connotation of lack of strong feeling and an abdication of self: the classic movie *The Man in the Gray Flannel Suit* portrayed the frustrating lack of autonomy in American corporate life. In nature, however, gray is a common color that provides camouflage, as in gray wolves, gray whales, and gray elephants, which may explain the otherwise puzzling popularity of noncommittal gray clothing in the business world.

Piet Mondrian (1872–1944), *Composition: Light Colour Planes with Grey Contours*, 1919, oil on canvas, 49 × 49 cm (19¼ × 19¼ in.). Basel, Kunstmuseum, Offentlich Kunstsammlung. © 2004 Mondrian/Holtzman Trust/Artists Rights Society (ARS), New York.

The gray lines both bind and separate the planes of pale color, with an overall effect of indefiniteness.

The painting may reflect the ennui of post–World War I Europe. At the time of this painting, Mondrian wrote: "I use those mute colours for the time being, adjusting to present day surroundings and the world; this does not mean I would not prefer a pure colour."

In Mondrian's later paintings, the grid lines became black and the colors became full intensity reds, blues, and yellows.

Scan your paintings for your use of gray. It is more likely to appear in your rendition of "Sadness" and "Winter" than in your paintings of "Joy" and "Spring," but be prepared for some surprises. Gray may show up in your painting of "Love," suggesting indecision, or in "Jealousy," signifying withdrawal from conflict.

Practicing Your Understanding of the Meaning of Colors

Your set of paintings and the summarizing notes you have made of them represent the gains you have made in learning the basic structure of color, and the insight you have achieved in understanding your personal color vocabulary. This knowledge can be useful in everyday life, since all of us continually face color choice decisions, whether in clothing, house paint, furniture, accessories, gifts, or gardening.

In most of these areas, the goal is generally to select harmonious colors, not discordant colors—unless, of course, your personal preference is for discordant colors, sometimes called "clashing colors." They can be startlingly beautiful—for example, high-intensity purple, red-orange, yellow-green, and blue, all in one room—and our modern tastes have become much more accepting of discordant colors. Most of us, however, will not want our brains jarred to that extent on a daily basis, and we will opt for color harmony in our surroundings.

The solution to color-choosing problems lies in knowing your color preferences and the subjective meaning of colors, added to your knowledge of how to harmonize a set of colors by providing what the brain seems to long for: complementary colors, varied by transforming the original colors and their complements to varied values and intensities.

The harmonizing process, as you have seen, is quite simple and straightforward. You can start with one color that you like (a color that will convey the meaning you intend) and take the first step by adding its direct complement at the same value and intensity level. The next step is to transform both of the complementary colors to their opposite value and intensity levels. In this way, you will end with a set of harmonized colors that is satisfying to the eye and brain.

Of course, this is only one method of creating beautiful color harmonies. Analogous colors (hues that lie next to each other on the color wheel) are inherently harmonious, as are monochromatic schemes that are value and intensity variations of one color. Conversely, you can avoid using colors altogether and work out an *achromatic* design in shades of gray, black, and white. Most of us, however, love complementary colors, and, as you have seen, the human brain seems also to seek that combination, especially when the hues are harmonized by the method you have learned.

Writer and gardener Celia Thaxter provides a glimpse of her delight in a common wildflower:

"Eschscholtzia — it is an ugly name for a most lovely flower. California Poppy is much better... One blossom I take in a loving hand the more closely to examine it... Every cool gray-green leaf is tipped with a tiny line of red, every flower-bud wears a little pale-green pointed cap like an elf.

[The flower] is held upright upon a straight and polished stem, its petals curving upward and outward in the cup of light, pure gold with a lustrous satin sheen; a rich orange is painted on the gold, drawn in infinitely fine lines to a point in the center of the edge of each petal, so that the effect is that of a diamond of flame in a cup of gold...

In the center of the anthers is a shining point of warm sea-green, a last, consummate touch which makes the beauty of the blossom supreme."

Thaxter, *An Island Garden*, 1894

Using Your Color Knowledge

The practical applications of your study of color are many and varied, but, in addition, knowledge of color brings its own kind of pleasure. Because we are surrounded by color, you will find yourself noticing and thinking about the meaning of colors in unexpected places—for example, in advertisements, in colors people choose for clothing and cars, in holiday decorations, in international flags, in the color of both the exteriors and interiors of buildings, and corporate color identities. This is excellent practice for keeping your color knowledge alive and growing. Also, many writers use color symbolism to express the nature of people and places, and understanding the meaning of colors can make reading a richer experience.

Another interesting way to practice your color skills is to consciously take notice of complementary colors as you go about your daily life. You may be surprised at how enriching such a simple practice can be.

To practice your color-mixing skills, a very useful habit is to pause a moment when you notice a color (perhaps something in the landscape), again, pausing long enough to really *see* the color, even scanning it through your cupped fist in order to isolate the hue from its surrounding hues. (People will ask, "What *are* you doing?") Once you have seen the color, name it by its attributes, and think *how you would mix that hue*. Which of twelve pigments would you start with as the source hue, and what would you use to adjust the value and intensity levels? For example, you might have noticed the pale yellow-green of a fern against the darker hue of a clipped cypress hedge. You can practice mixing these colors in your mind, first the pale fern color, then the darker hedge color, and you will find that this practice will transfer directly into greater certainty in actually working with colors.

Realistically speaking, however, the overarching goal of teaching yourself how to see colors is to experience

again and again your aesthetic response to the beauty of the world and to discover your unique way expressing of that beauty. As artist and teacher Robert Henri wrote, "There are moments in our lives, there are moments in a day, when we seem to see beyond the usual—become clairvoyant. We reach then into reality. Such are the moments of our greatest happiness. Such are the moments of our greatest wisdom."

My hope is that you will see color in ways you never did before you embarked on this study of color, and that you will persist in striving to discover the meaning of your own unique color vocabulary. When a person, a flower, a landscape, a painting—or something as ordinary as a tray of green apples on a dark wooden table—catches your attention, I hope that you will reexperience the energizing high of the aesthetic response.

Of course, the best possible way to practice your color skills is to continue painting. I know of no better way to slow down perception and see color in all of its complex relationships. Color is a study without end, because you will always feel, as every painter feels, that even though your last effort was flawed, your *next* effort to depict the beauty of color may be the one wherein nature will yield some of her secrets.

"It is the aesthetic that represents the highest form of intellectual achievement, and it is the aesthetic that provides the natural high and contributes the energy we need to want to pursue an activity again and again and again."

Elliot Eisner, "The Kind of Schools We Need," 2002

Fig. 12-27. Farber, *Story of the Eye.*
See large detail on page 82.

Glossary

Achromatic. Literally, without color. In art, a composition in shades of black, white, and gray.

Additive. Colors made by light; the additive primaries are red, green, and yellow.

After-image. The illusion of a visual complementary color image that occurs after staring at a hue, then shifting the gaze to a plain white surface.

Analogous hues. Colors that lie next to each other on the color wheel.

Attributes of color. The three main descriptions or properties of colors, namely, hue, value, and intensity.

Balanced color. Colors that are balanced by their complements and varied across their values and intensities.

Binocular vision. Two retinal images, one from each eye, melded by the brain's visual system into a single image that appears three-dimensional.

Chroma. The degree of purity or brilliance of a color. See *intensity*.

Chromaticity. A term interchangeable with chroma, saturation, and intensity.

Color constancy. The psychological tendency to see colors we expect to see even when the actual colors are different.

Color harmony. The pleasing result of balanced color relationships.

Color scheme. A set of colors chosen to combine within a composition.

Color wheel. A two-dimensional circular arrangement of colors that reveals color relationships of the spectral hues.

Complement, complementary. Colors that lie opposite each other on the color wheel. Placing them side by side enhances the brilliance of both; mixed together, they cancel the intensity of both.

Composition. The arrangement of shapes, spaces, lights, darks, and colors within the format of an artwork.

Cool colors. Colors that connote the coolness of water, dusk, and vegetation: usually violets, blues, and greens.

Crosshatching. A method of shading by using short parallel lines, often in superimposed sets of lines crossed at various angles to darken an area.

Double complementary. A color combination of four hues: two sets of complements such as red/green and blue-violet/yellow-orange.

Dyad. A color scheme based on two colors.

Glaze. A transparent film of color painted over another color.

Grisaille. A method of painting that uses shades of gray in an underpainting to establish the value structure of a composition.

Hue. The name of a color.

Intensity. The brightness or dullness of a color; also called chroma, chromaticity, and saturation

Line. A narrow mark that defines the edges of spaces and shapes in a composition. Line can also be used for shading, as in crosshatching.

L-mode. The language mode of the brain, usually located in the brain's left hemisphere and characterized as a verbal, analytic, and sequential mode of thought.

Local color. The actual color seen on objects or persons. See *perceptual color*.

Luminosity. In painting, the illusion of radiance or glow.

Monochromatic. In painting, a work based on variations of one color.

Monocular vision. By closing or covering one eye, the brain receives a single image, which appears to be flat like a photograph.

Negative spaces. In art, the shapes that surround the objects; sometimes considered background shapes.

Palette. A surface for holding pigments and providing space for mixing paints.

Perceptual color. The actual colors of objects and persons. See *local color*.

Pictorial color. The adjustments to perceptual color needed to bring a color composition into unity, balance, and harmony.

Pigment. Dry color ground to a fine powder and mixed with a liquid for use as a painting medium.

Primary colors. Colors that cannot be mixed from any other colors—for example, red, yellow, and blue.

Reflected color. Color reflected from one surface to another.

R-mode. The visual mode of the brain, usually located in the brain's right hemisphere and characterized as a visual, perceptual, and global mode of thought.

Saturation. A term signifying the brightness or dullness of a color: used interchangeably with intensity, chroma, and chromaticity.

Secondary colors. Colors that are mixtures of two primaries—for example, mixing yellow and red (theoretically) makes orange.

Shade, shading. In Ostwald's model, color changes made by adding black, thus decreasing the proportion of the original color.

Simultaneous contrast. The effect of one color on an adjacent color.

Spectrum, spectral hues. The sequence of colors seen in a rainbow or in the colors created by passing light through a prism.

Style. An artist's personal, usually recognizable, manner of working with images and art materials.

Subtractive color. Pigments and pigment mixtures used in painting that absorb all wavelengths except those of the color or colors apparent to the eye.

Successive contrast. Interchangeable with after-image.

Tertiary colors. Colors made by mixing a primary and its adjacent secondary—for example, the tertiary yellow-orange results from mixing the primary yellow and the secondary orange.

Tetrad. A color scheme based on four hues equidistant on the color wheel—for example, green, yellow-orange, red, and blue-violet.

Tint. A light value of a color.

Toned ground. A thin wash of a neutral color on a surface to prepare it for painting.

Triad. A color scheme based on three colors equally spaced from each other on the color wheel—for example, yellow, red, and blue.

Underpainting. A preliminary toning of the surface to be painted, often somewhat more detailed than a toned ground.

Unity. The ruling principle of art and design, that all parts of an artwork contribute to the harmonious unity of the whole.

Value. The degree of lightness or darkness of a color.

Warm colors. Colors associated with heat or fire, such as red, orange, and yellow.

Bibliography

Albers, Josef. *The Interaction of Color*. New Haven, Conn.: Yale University Press, 1963.

Bloomer, Carolyn M. *Principles of Visual Perception*. New York: Van Nostrand Reinhold, 1976.

Blotkamp, C., et al. *De Stijl, The Formative Years, 1917–22*. Cambridge, Mass.: The MIT Press, 1986.

Brusatin, Manlio. *A History of Colors*. Boston and London: Shambala, 1991.

Carmean, E. A. *Mondrian: The Diamond Compositions*. Washington, D.C.: National Gallery of Art, 1979.

Chevreul, M. E. *The Principles of Harmony and Contrasts of Color*. New York: Van Nostrand Reinhold, 1967.

Chomsky, Noam. *Language and Mind*. New York: Harcourt, Brace & World, 1968.

Davidoff, Jules. *Cognition Through Color*. Cambridge, Mass.: The MIT Press, 1991.

Delacroix, Eugène. *The Journal of Eugène Delacroix*. English translation by Walter Pach. New York: Covici Friede, 1937.

Edwards, Betty. *The New Drawing on the Right Side of the Brain*. New York: Tarcher/Putnam, 1999.

———. *Drawing on the Artist Within*. New York: Simon & Schuster, 1989.

Eisner, Elliot. "The Kind of Schools We Need," *Kappan* 83, no. 8 (April 2000).

Gage, John. *Color and Culture*. Berkeley, Calif.: University of California Press, 1993.

Gerritsey, Frans. *Evolution in Color*. Westchester, Penn.: Shiffer Publications, 1988.

Goethe, Johann Wolfgang von. *Farbenlehre*. English translation by Charles Lock Eastlake, introduction by Deane B. Judd. Cambridge, Mass.: The MIT Press, 1970.

Gordon, R., and A. Forge. *The Last Flowers of Manet*. New York: Harry N. Abrams, 1986.

Henri, Robert. *The Art Spirit*. New York: Harper & Row, 1923.

Hopkins, Gerard Manley. *The Later Poetic Manuscripts of Gerard Manley Hopkins in Facsimile*. Edited by Norman H. MacKenzie. New York and London: Garland Publishing, 1991.

Hospers, J. *Meaning and Truth in the Arts*. Chapel Hill: University of North Carolina Press, 1976.

Itten, Johannes. *The Art of Color*. New York: Reinhold Publishing Corp., 1961.

Kandinsky, Wassily. *Concerning the Spiritual in Art*. English translation by M. T. H. Sadler. New York: Dover Publications, 1977.

Knight, Christopher. "A Pivotal Call to Colors." *Los Angeles Times Calendar*, March 23, 2003.

Leonardo da Vinci. *A Treatise on Painting*. English translation by J. F. Rigaud. London: George Bell & Sons, 1877.

Lindeuer, M. "Aesthetic Experience: A Neglected Topic in the Psychology of the Arts." In D. O'Hare (ed.), *Psychology and the Arts*. Brighton: Harvester Press, 1981.

Lindsay, K., and P. Vergo. *Kandinsky: Complete Writings on Art*. Boston: G. K. Hall & Co., 1982.

Mecklenburg, Virginia M. *The Patricia and Phillip Frost Collection: American Abstraction, 1930–1945*. Washington, D.C.: National Museum of American Art and Smithsonian Institution Press, 1989.

Munsell, Albert. *A Color Notation*. Baltimore: Munsell Color Company, 1926.

———. *A Grammar of Color*. Edited and with an introduction by Faber Birrin. New York: Van Nostrand Reinhold, 1969.

Newton, Sir Isaac. *Opticks*, 1706.

Nunally, J. "Meaning-processing and Rated Pleasantness," *Scientific Aesthetics* 1 (1977): 168–81.

Ostwald, Wilhelm. *Color Science*. English translation by J. Scott Taylor. London: Winsor & Newton, 1931.

Riley, Bridget. "Color for the Painter." In *Color: Art and Science*. Edited by T. Lamb and J. Bourriau. Boston, Mass.: Cambridge University Press, 1995.

Rood, Ogden. *Modern Chromatics*. New York: Van Nostrand Reinhold, 1974.

Rossotti, Hazel. *Colour: Why the World Isn't Grey*. New Jersey: Princeton University Press, 1983.

Runge, Philip Otto. *Die Farbenkugel*. Stuttgart: Verlag Freies Geistesleben, 1959.

Ruskin, John. *Selected Writings*. Selected and annotated by Kenneth Clark. New York and London: Penguin Books, 1982.

Stephan, Michael. *A Transformational Theory of Aesthetics*. London: Routledge, 1990.

Stern, Arthur. *How to See Color and Paint It*. New York: Watson-Guptil Publications, 1984.

Theroux, Alexander. *The Primary Colors*. New York: Henry Holt & Co., 1994.

Van Gogh, Vincent. *The Complete Letters of Van Gogh*. Greenwich, Conn.: New York Graphic Society, 1958.

Verity, Enid. *Color Observed*. New York: Van Nostrand Reinhold, 1980.

Wittgenstein, Ludwig. *Remarks on Color*. Edited by G. E. M. Anscombe, translated by L. McAlister and M. Schaettle. Oxford: Blackwell, 1978.

Index

Twelve-color wheel, 18